IMAGES
of America

BROWARD COUNTY
The Photography of
Gene Hyde

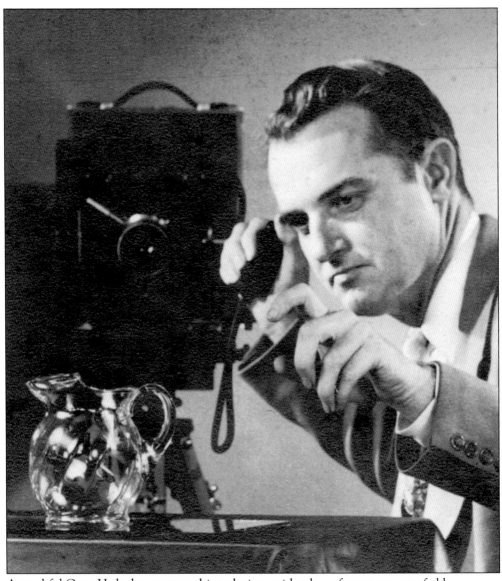

A youthful Gene Hyde demonstrates his technique with a large format camera of old.

IMAGES
of America

BROWARD COUNTY
The Photography of Gene Hyde

Susan Gillis

ARCADIA
PUBLISHING

Published by Arcadia Publishing
Charleston, South Carolina

Printed in the United States of America

Library of Congress Catalog Card Number: 2005925057

For all general information contact Arcadia Publishing at:
Telephone 843-853-2070
Fax 843-853-0044
E-mail sales@arcadiapublishing.com
For customer service and orders:
Toll-Free 1-888-313-2665

Visit us on the Internet at www.arcadiapublishing.com

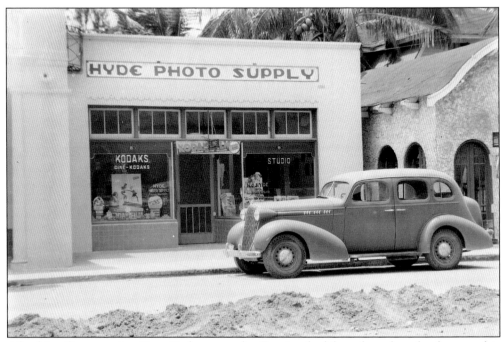

After his military service, Gene Hyde returned to Fort Lauderdale and purchased a photographic shop at 29 Northwest First Avenue in the early 1950s.

CONTENTS

ACKNOWLEDGMENTS

Gene Hyde was a longtime supporter of Broward's history and friend of the Fort Lauderdale Historical Society, contributing images to that agency on a variety of projects in the 1970s. In the 1980s, Gene began donating his large collection of negatives to the historical society. He realized their value in the documentation of the history of what was clearly a vastly changed, rapidly evolving county. I served as the curator of collections at the Fort Lauderdale Historical Society for many years. In that time, I became acquainted with Mr. Hyde and his collection by working on its catalogue, assisting research patrons, and compiling exhibitions and publications using his photographs. I realized that there were literally thousands of well-composed, professional quality images never before viewed by the general public. My thanks to the Fort Lauderdale Historical Society staff, the Broward County Historical Commission, and other friends and agencies who have assisted with this effort to promulgate Gene Hyde's work and to bring Broward County's history to life.

Photographs courtesy the Gene Hyde Collection, Fort Lauderdale Historical Society.

Gene Hyde, Broward County photographer, is shown here.

INTRODUCTION

Vacation land for the nation, Broward County has drawn permanent residents by the hundreds of thousands in the last few years. New friends, new people, new business . . . Broward has a way of attracting them all—for keeps! How did we get so lucky? This is how . . . balmy climate, shore and sea, wonderful cities, warmth, leisure activities, ALL YEAR!
—(c. 1965 promotional ad by the Broward County Economic Development Commission)

The earliest known inhabitants of what is today known as Broward County, Florida, were a resourceful people known as the Tequesta Indians. For several thousand years, they exploited the bountiful resources and equable climate much as its modern residents do today. Those ancient people were long gone by the end of the 18th century—when the first Bahamian and American settlers arrived on New River. By the end of the 19th century, a small community huddled on that river, named Fort Lauderdale in honor of a fortification that arose there during the Second Seminole War. By 1896, the Florida East Coast Railway was completed between Palm Beach and Miami—and civilization began in earnest up and down that route. New towns grew at Deerfield, Pompano, Fort Lauderdale, Dania, and Hallandale. In 1915, these communities joined together to form a new county, carved out of Dade County to the south and Palm Beach County to the north. The new county was named after the Florida governor who had championed the Everglades drainage program that had brought economic prosperity to the region—Napoleon Bonaparte Broward.

The Florida land boom of the 1920s introduced two new industries to Broward: tourism and land development. New towns were borne amidst the influx of land-hungry residents. Hollywood-by-the-Sea was typical of the Florida land boom communities, the brainchild of developer Joseph Young. After World War II, a new era of growth gripped the area, and 22 additional municipalities were created in the county by 1967.

Fort Lauderdale photographer Aaron Gene Hyde was one of the principle documentarians of those amazing years as vast tracts of land morphed from farm and dairy country to subdivisions. Gene came with his family to Fort Lauderdale in 1933, at the age of 16. He brought with him a strong interest in photography, and his rare 1930s images are some of the best that survive of Fort Lauderdale during the Depression years. He gained additional professional training at the Brooks Institution of Photography in Santa Barbara and other schools. During the war, he served in the Signal Corps making active use of his photographic skills. He gained experience with motion pictures there, working alongside director John Huston, among others.

After the war, Gene returned to Fort Lauderdale and began a career that was to span another 40 years. As one of the county's few professional photographers, Gene was called upon to shoot a wide range of subjects—from weddings to autopsies, passport shots to presidents. He served for many years as the photographer for the Broward edition of the *Miami Herald*, as well as a United Press International (UPI) and Associated Press (AP) photographer. His photojournalism led him to record many fascinating people, places, and times, pivotal in the development of the county, such as spring break and the African American community's campaign for desegregation. The large vintage automobiles and demurely covered beachgoers featured in Gene's photos invoke in its viewers nostalgia for the not-all-that-distant past, a way of life Broward County residents will never see again.

For Gene, photography was not just a job. His practiced eye, keen sense of composition, and technical expertise (in the days before "point and shoot") captured the most mundane venue with the eye of an artist. His 1950s-era vignettes, shot with a large format camera, sometimes seem almost Rockwellian—with South Floridians as his principle characters. The excellent details of everyday life that appear in these images—the activities, fashions, technology, and venues—are an anthropologist's dream and proof that pictures can be worth a thousand words.

Gene's wry sense of humor belied a generous and thoughtful man. In the 1980s, he donated approximately 200,000 negatives to the Fort Lauderdale Historical Society to be preserved for posterity. Gene's images have in turn been used in publications, exhibitions, and as historical decor in endless local establishments. The collection spans the era from the 1930s (there are very few of these, however) through the 1970s. Most of Gene's photojournalistic images were shot in the 1950s and 1960s, and consequently, most of the images used in this volume date from those two decades. Mr. Hyde passed away in 2004, unable to complete his dream of creating a book based on his life's work. The Fort Lauderdale Historical Society and I hope that this compilation will give readers a taste of his vast body of work and an appreciation for his artistry and the skill with which he captured Broward County history.

Readers should bear in mind that although this book is about Broward County, it is Gene Hyde's Broward County that we visit here. The towns and events he recorded were assignments for some newspaper, UPI, or a commercial contract. So there are cities in the county that are surprisingly absent—Coral Springs, for example. Of course, most of the photos are of Fort Lauderdale—that was "downtown" for most of the county, after all. And you newbies like Weston and Southwest Ranches, well, you'll have to find your own photographer.

Here are the towns and communities (some no longer extant) represented in *Broward County: The Photography of Gene Hyde*:

SENIOR CITIZENS: Dania Beach, Davie, Deerfield Beach, Fort Lauderdale, Hallandale, Hollywood, Hollywood Seminole Indian Reservation, Oakland Park, Pompano Beach.
MIDDLE AGED: Carver Ranches, Collier City, Lauderdale-by-the-Sea, Lauderhill, Lazy Lake, Lighthouse Point, Margate, Miramar, North Andrews Gardens, Pembroke Pines, Plantation, Sunrise, Wilton Manors.
GONE BUT NOT FORGOTTEN: Andytown, Hacienda Village, Jo-Mo City.

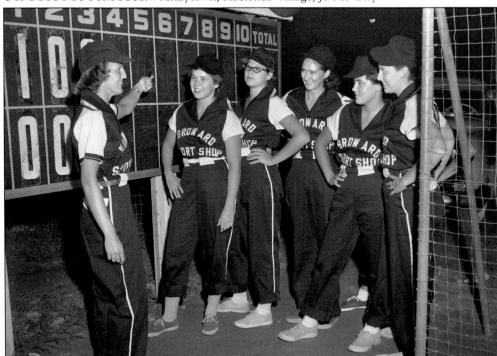

The local baseball fields weren't just for "the boys," as evidenced by this *c.* 1956 shot of the Broward Sport Shop's women's softball team at Davis Field, the diamond located at Southside (today Hardy) Park in Fort Lauderdale. (H10535.1)

One

THE EVERYDAY

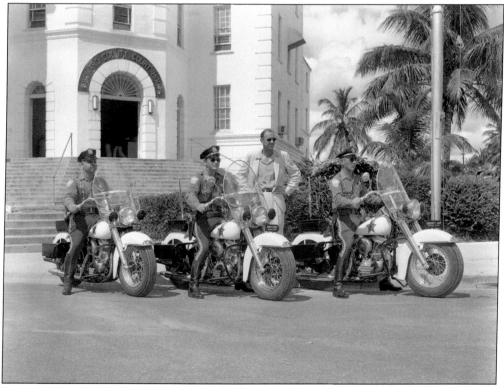

Broward Sheriff's Department motorcycle deputies pose in front of the c. 1928 Broward County Courthouse steps in 1952. Soon after, the courthouse was extensively remodeled section by section; today the section seen in this view has been completely replaced by newer construction. (H8352.1)

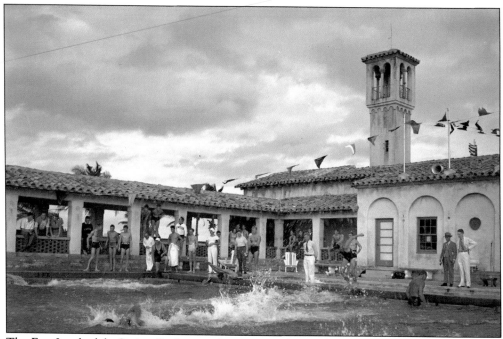

The Fort Lauderdale Casino Pool opened in 1928 at the south end of the beach, to the east of today's International Swimming Hall of Fame. A beloved venue, it served as a key recreational facility for countless local residents until its demolition in the 1960s. In this picture, Gene Hyde documents the 1936 annual Collegiate Aquatic Forum in progress. (H36.4)

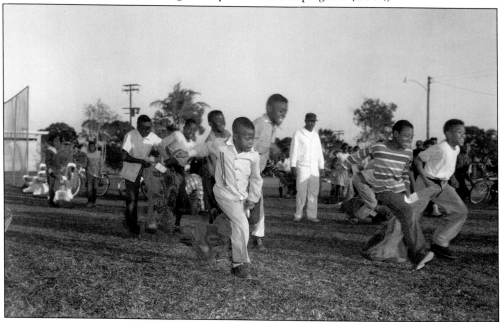

By 1951, Sunland Park, which served Fort Lauderdale's then-segregated African American community, was renovated to include a much-needed swimming pool and 16 additional acres. Today it serves the public as Joseph Carter Park. Here, young park patrons engage in a three-legged race in 1956. (H9362.1)

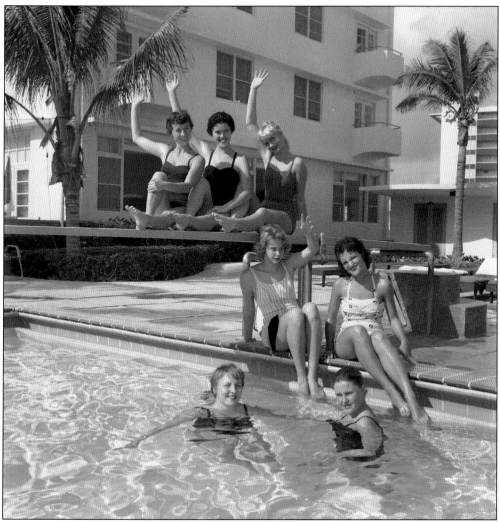

A bevy of requisite bathing beauties pose for the photographer beside the pool at the Sunspa Hotel on Hallandale Beach, just south of the Diplomat, c. January 1959. The moderne-styled Sunspa fell to the wrecking ball in 2002. (H17907A.4)

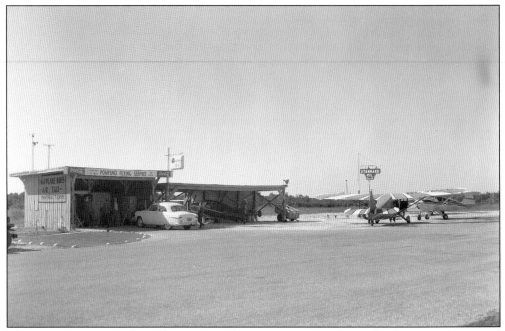

The Pompano Airport, shown here in its infancy in 1956, was a former landing strip that served training flights from the Fort Lauderdale Naval Air Station during World War II. Good flying weather, an influx of new residents, and abandoned military airfields help spur the development of the aviation industry in Broward. (H9110.2)

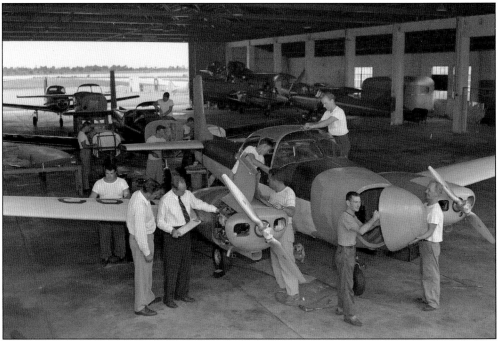

One of Fort Lauderdale's more interesting mid-20th-century businesses was Riley Aircraft, which operated out of Broward County International Airport (now Fort Lauderdale/Hollywood) in 1952. Riley converted DeHavilland Navion aircraft into twin-engine executive-style aircraft. (H218.1)

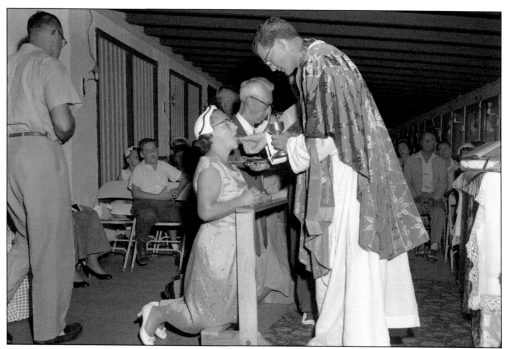

Parishioners at the newly founded St. Clement's Catholic Church receive mass about 1953. The congregation first met at Rivercrest Farm Dining Room, a restaurant across from the present Fort Lauderdale High School on Northeast Fourth Avenue. (H4321.2)

A newly married couple exits the beautiful St. Anthony's Catholic Church at 901 Northeast Second Street in Fort Lauderdale in 1953. Gene Hyde was both a photojournalist and studio photographer. Like many photographers, weddings were his bread and butter. (H190.4)

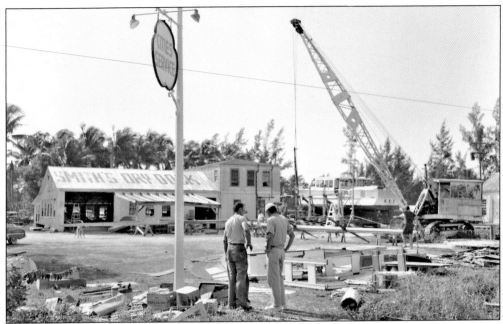

The marine industries had been an important part of the Fort Lauderdale economy since the earliest pioneer days. Smith's Dry Dock, shown here in 1952, replaced the earlier Dellevig's New River Boat and Engine Works at Tropical Point (Southwest Eleventh Avenue on New River). Smith's boasted a marine railway and constructed steel harbor tugs for the U.S. Army in this era. (H156.1)

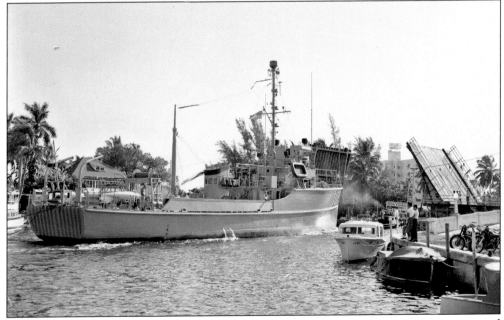

On August 9, 1953, Broward Marine tows the first of its non-magnetic minesweepers constructed under a navy contract to Port Everglades. Minesweeper #109 was destined for use by the Dutch Navy. Here the vessel creeps through the opening at the Federal Highway Bridge (now the site of the tunnel). The Stranahan House (then Pioneer House Restaurant) is visible at left. (H1640.2)

In about 1957, the famous Chris Craft boat manufacturer brought its headquarters to Pompano Beach, shown here at its location south of what is now Atlantic Boulevard at Andrews Avenue. By 1977, it had become the world's largest builder of pleasure boats. Above is an exterior and below an interior shot of the plant in October 1957. (H15030.2 and H14734.1)

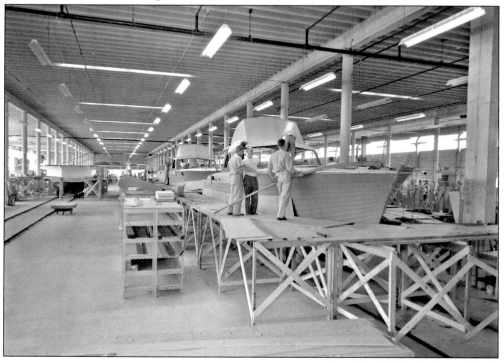

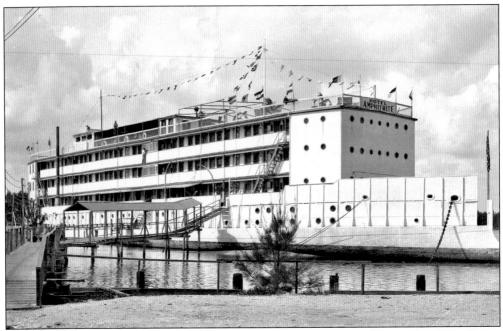

One of Fort Lauderdale's unusual attractions during the 1930s was the floating hotel *Amphitrite*, a former U.S. Navy monitor that had served during the Spanish-American War. A very young Gene Hyde documented the hotel in its third location at the former island at the center of the Las Olas Causeway c. 1936. (H383A.4)

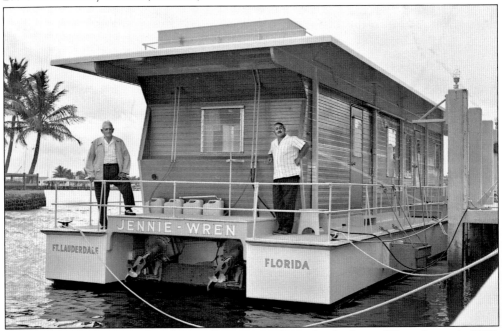

A house trailer serves as a fine floating home, as evidence by the *Jennie-Wren*, shown in 1960. Although this example is equipped with engines, many non-powered floating domiciles were not, and they were once common along Fort Lauderdale's waterways. The latter were banned from New River by 1972, changing the face of the river. (H20291.2)

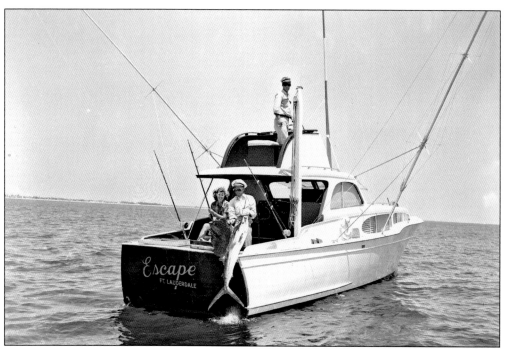

By the 1930s, Fort Lauderdale was well known as a mecca for small pleasure craft and game fishing. Here a tourist reels in a sailfish off the coast aboard the *Escape* in the early 1950s. (H47792.3)

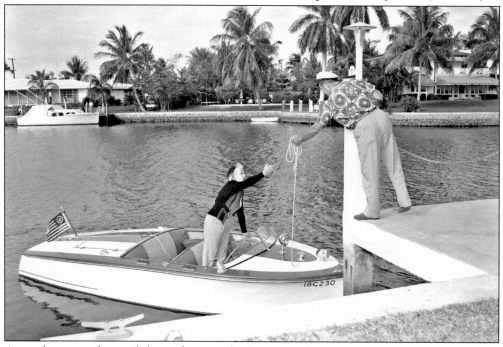

A couple ties up their stylish runabout on the Intracoastal Waterway in the mid-1950s, a scene reenacted by boating enthusiasts up and down Broward's many waterways. With the growing popularity of fiberglass boats and the draw of waterfront living, Broward's marine industries enjoyed a tremendous growth at mid-20th century. (H47795.2)

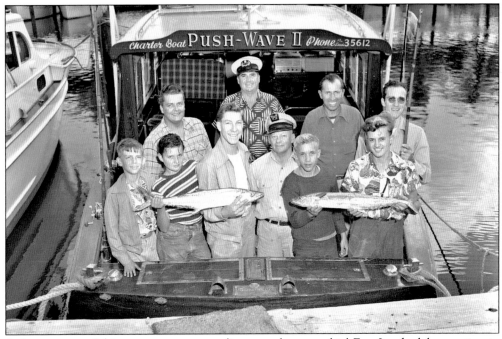

A day out game fishing was a necessary adjunct to the proverbial Fort Lauderdale vacation in the 1950s. This happy group of men and boys pose with their hard-earned catch aboard the *Push Wave II* charter boat, c. 1952. (H143.1)

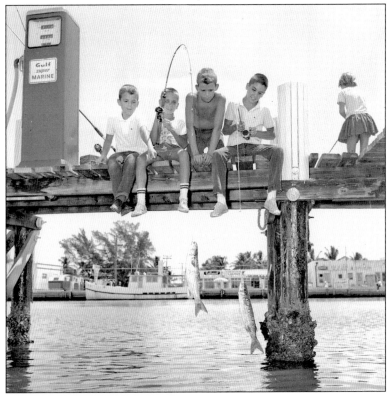

Fishing was not just a tourist pastime. These young anglers reel in a few on a dock on the west side of the Intracoastal, near the present Holland Park at about Johnson Street, during a Hollywood fishing expedition in August 1962. (H29860.5)

Gene poses for his own camera in this scene of happy fishermen fresh home from a day aboard Cap Vreeland's *Kingfisher IV* in 1935. Pictured at the Andrews Avenue docks on New River are, from left to right, Mr. H. S. Wood, H. G. Hyde, Hyde's son Gene, Captain Reed, and H. E. Reed.

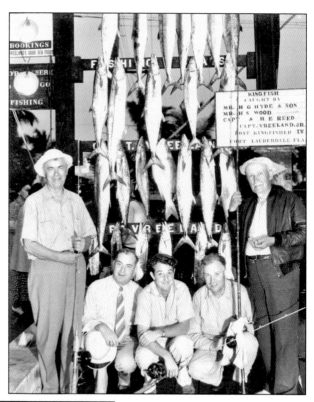

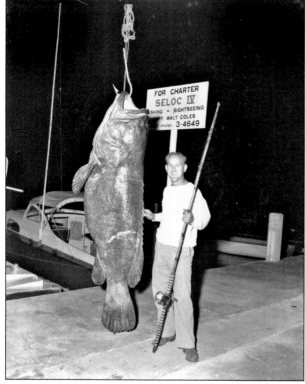

Another satisfied customer poses with an impressive grouper caught aboard the *Seloc IV*, headquartered at the Gateway Docks in Fort Lauderdale, *c.* 1952. (H296.1)

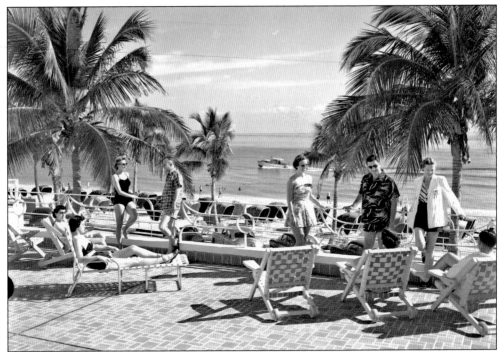

In the post–World War II era, Broward County experienced a surge in tourist traffic like never before. Towns once known for their tomato crop groomed their new image of "resort community." Above, guests at the Fort Lauderdale Beach Hotel bask in the sun of the first-floor deck overlooking an idyllic ocean scene; below, they engage in a round of shuffleboard on the hotel's "boardwalk" on the beach, both *c.* 1952. (H183.1A and H185.2A)

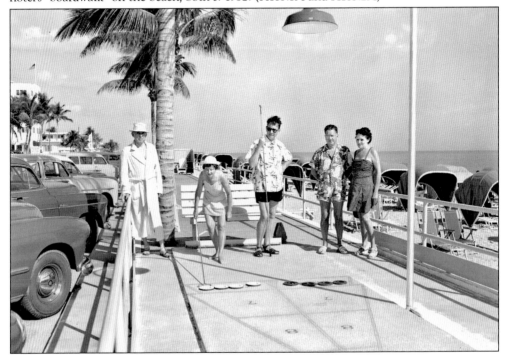

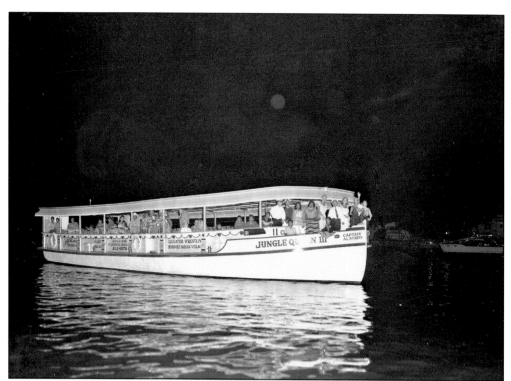

The first of the *Jungle Queen* river excursion boats began plying the waters of New River in 1935. The *Queen* featured a waterways tour, sing-alongs and other entertainment, and a stop at an island in New River for a barbecue and a visit to a "Seminole Indian village." Above, the *Jungle Queen III* returns home with Capt. Al Starts and some of the Seminole employees at the bow in 1966. At right, Captain Al joins the tour at a demonstration of alligator wrestling at the village in 1961. (H43331.3A and H47799.1)

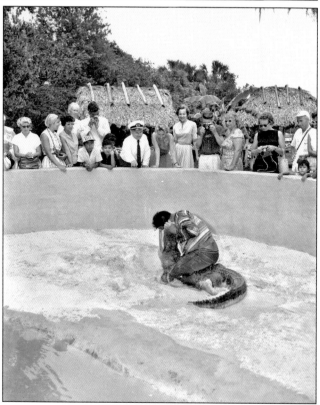

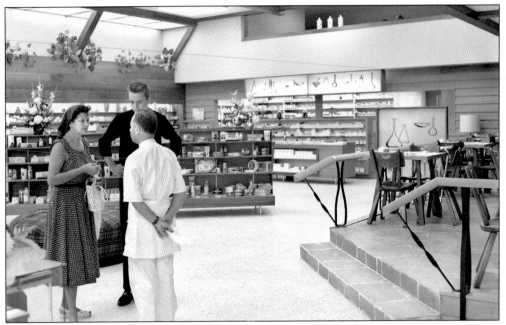

In 1956, a Fort Lauderdale landmark opened at 817 East Las Olas Boulevard—The Chemist Shop. Although it served as a convenient downtown drugstore, The Chemist Shop was best known for its coffee shop—where the "breakfast club" met to hash out local issues every morning until 1997, when it closed to move to a new location. This photo was taken in January 1957. (H12374.1)

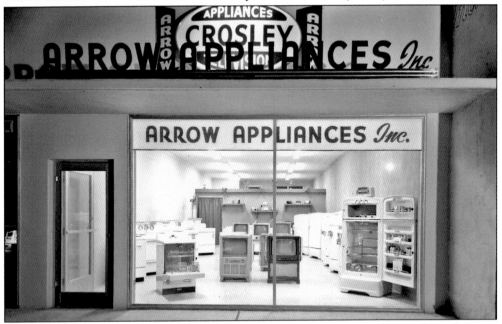

In 1952, the latest in modern appliances beckon to shoppers from the window of Arrow Appliances, located at 712 Northeast Sixth Avenue. Television was still new to South Florida—broadcasting had begun at WTVJ in 1949—and there still wasn't a whole lot to watch on those new television sets. Electric refrigerators had largely supplanted the old-fashioned icebox in "modern" homes, but the electric dishwasher—now that was progress! (H222.1)

North of Fort Lauderdale and south of Pompano Beach, the city of Lauderdale-by-the-Sea was a sleepy oceanfront community until the Commercial Boulevard bridge was completed over the Intracoastal Waterway in 1965. Here, c. 1961, the locals find a sufficiency of life's amenities and services at The Mail Box gift store and post office, shown inside and out, located at 239 Commercial Boulevard. (H27767.2 and H27767.4)

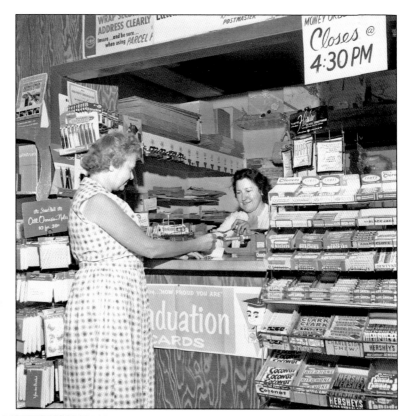

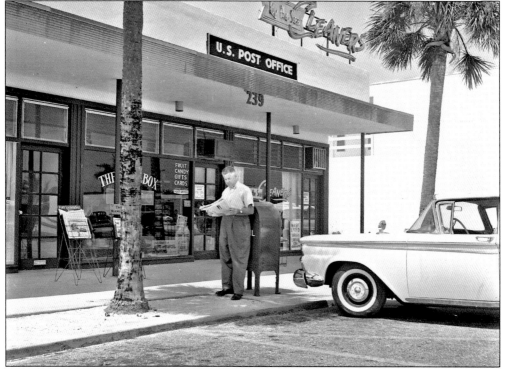

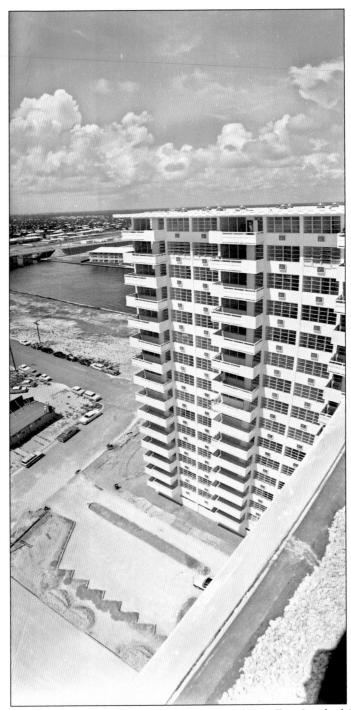

By the 1960s, a new type of residence was becoming popular in Fort Lauderdale—the hi-rise condominium. Co-ops and condos became particularly plentiful in one of the newly developed and prime sections of town—the Galt Ocean Mile. This interesting view, looking southwest from the first of the Coral Ridge Towers, reveals the Oakland Park bridge and Intracoastal in the background in 1962. (H29827.1)

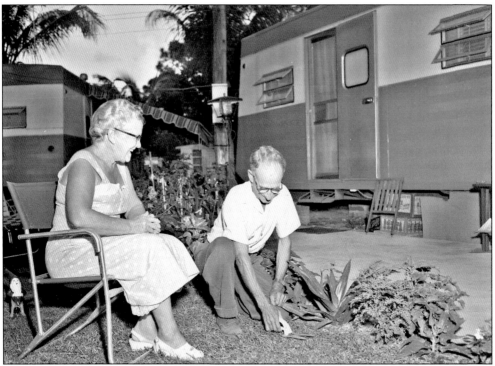

For many retirees or snowbirds coming to Broward County, a trailer or "mobile home" was a cost-effective alternative to housing. Above, a couple enjoys a warm Florida evening at the Middle River Trailer Park located at 1224 Northeast Twenty-fourth Street in Wilton Manors in early 1957. Below, a couple relaxes in their popular rattan furniture in a trailer somewhere in Broward in January 1962. (H12683.1 and H28777.12)

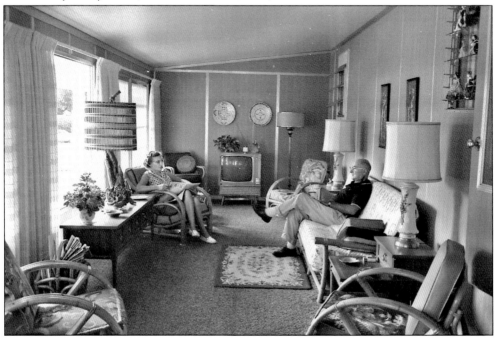

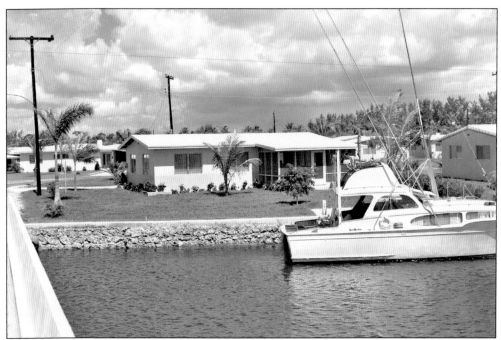

In the early 1950s, Gill Construction made the local homeowner's dream of "ocean access" more available than ever through their Lauderdale Isles development. The isles were modest mid-20th-century "cbs" homes built along canals extending off the south fork of New River south of Riverland Road, to the southwest of the city of Fort Lauderdale. Above, a good-sized cabin cruiser docks behind one of the new houses. Below, an interior shot features the open-air living in the days before central air-conditioning and the hip "modern" furnishings interior decorators now extol as "vintage." (H183.2 and H183.1)

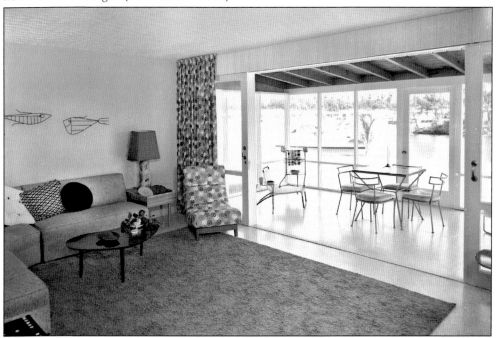

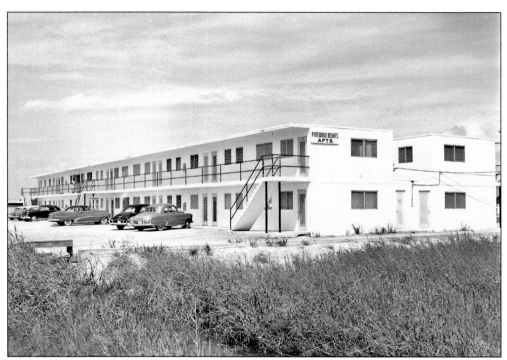

In 1959, the Pinewood Heights Apartments, a Blanche Ely Estate housing project, opened at 620 Northwest Seventh Avenue in Pompano to provide adequate housing for local African American families. Above is an exterior view of the prosaic apartment buildings (and some period automobiles of impressive size), and below, a mother and son enjoy their 1950s kitchen. (H19445.1 and H19445.2)

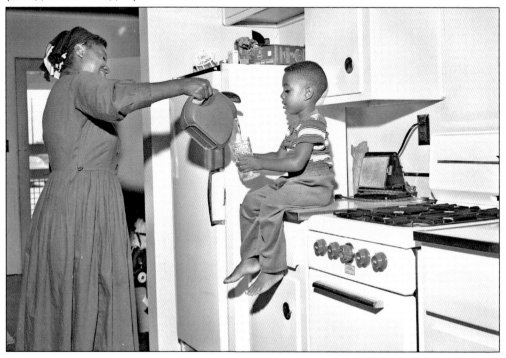

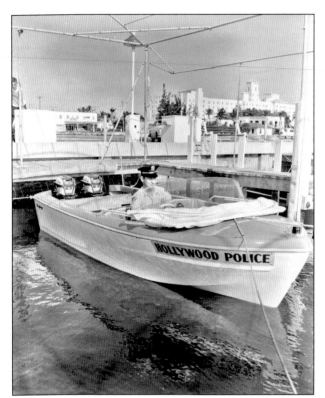

A Hollywood police officer poses in July 1958 with the department's newest crime-fighting equipment—a shiny pursuit boat—in the Intracoastal Waterway just north of the Hollywood Boulevard bridge. The Hollywood Beach Hotel rises in the right background. (H16862.3)

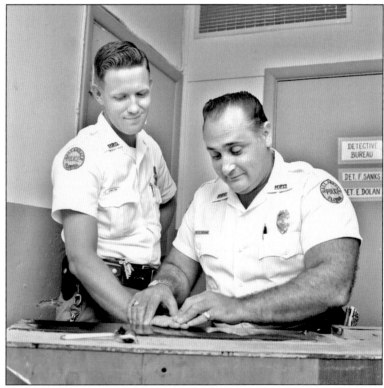

Two Hallandale police officers demonstrate a state-of-the-art technique (that is, in 1962) in forensic technology—fingerprinting. (H2909.1)

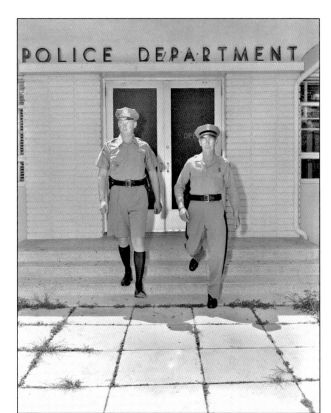

At right, in the early 1950s, Fort Lauderdale officers show off the newest uniform style at police headquarters, located in what was then city hall at 301 North Andrews Avenue. Below, Fort Lauderdale detectives, no doubt pleased to wear civilian dress, examine the booty from a bolita raid—the Cuban version of numbers running and a common form of illegal gambling in 1956. (H5167.1B and H9639.1)

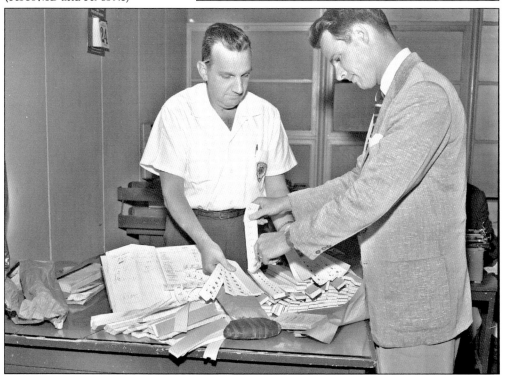

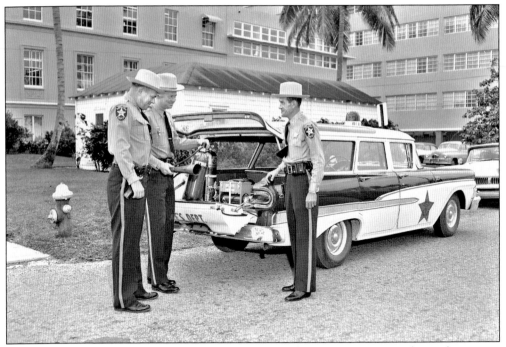

Broward sheriff deputies show off the latest uniforms and rescue equipment—the predecessor to the well-stocked paramedics' vehicles of today—at the rear of the Broward County Courthouse in 1957. (H15167.2)

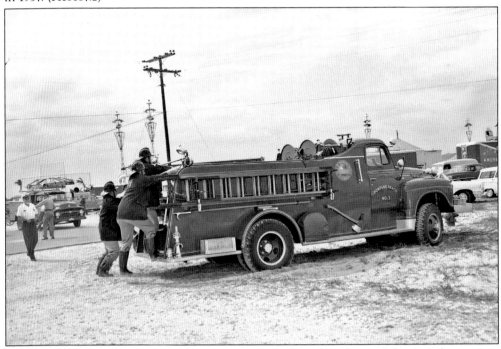

Pompano firefighters demonstrate their response procedure aboard one of the city's fire engines at Pompano's Golden Jubilee celebration in April 1958. Headquarters for the celebration was the Miller Amusement Jubilee Midway, located by the recreation park near the airport. (H16189.1)

In June 1958, a state wildlife officer demonstrates to law enforcement officers from around Broward County how to subdue one of Florida's more irascible criminals. (H16693.1)

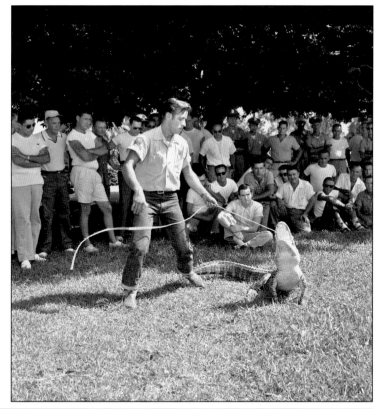

A scoutmaster demonstrates firearms safety to the members of Fort Lauderdale Boy Scout Troop 2, on bivouac at a local church c. 1952. (H214.2)

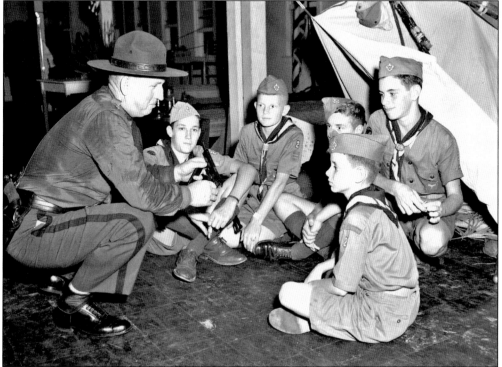

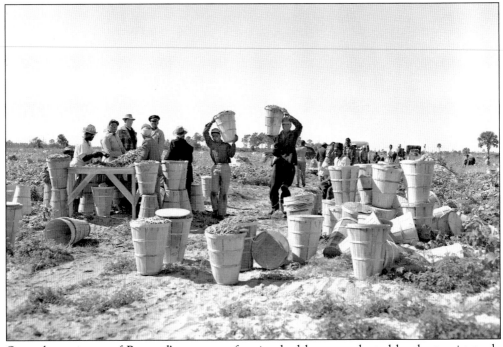

Once the mainstay of Broward's economy, farming had been supplanted by the tourist trade and the glitter of real estate throughout much of the county by the 1950s. In the north county, green beans, peppers, and other winter vegetables remained the primary source of revenue and employment. Above, workers harvest the bean crop near Pompano in 1953. Below, a woman carries water amidst the hovels that served as housing for the migrant community in the Pompano area c. 1956. (H267.4 and H10119.1)

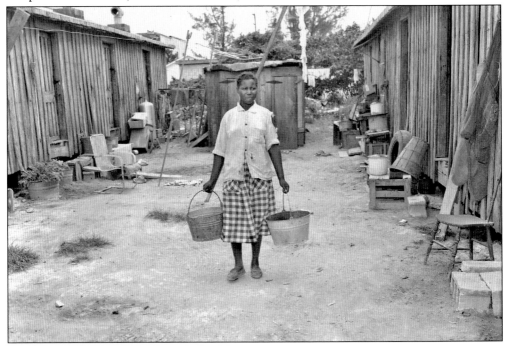

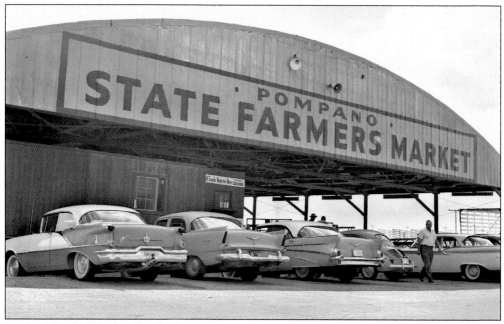

In the fall of 1939, the Florida Department of Agriculture designated Pompano as the site of one of the official state farmers markets. The market, located about a mile west of the Florida East Coast Railway tracks on Atlantic Avenue, grew to be the world's largest winter vegetable market, attracting local farmers from around Southeast Florida and buyers from throughout the nation. This photo shows the entrance about 1959. (H18089.5)

The city of Dania was well known for its tomato crop until saltwater intrusion destroyed the productivity of local fields. Here workers attend the line in a tomato-packing plant there c. 1959. (H18530.3)

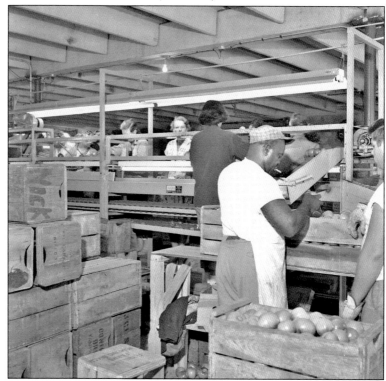

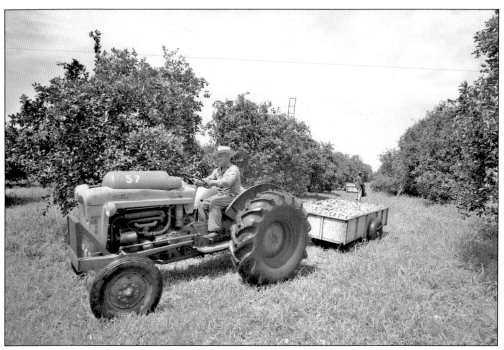

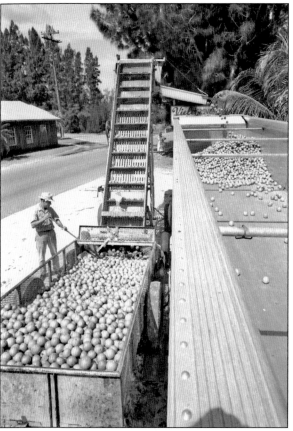

The Viele family members were amongst the hardy pioneers who braved primordial conditions, Florida style, to settle the newly drained Everglades land that became Davie. They soon realized their good fortunes in the citrus industry. Here, around the 1950s, oranges are harvested and sorted at the Viele Groves located on Griffin Road west of Davie Road. Today the groves are gone, supplanted by new development, but the Viele homestead has been relocated to the nearby Old Davie School museum complex. (H47805.3 and H47805.1)

Early settlers thought insect-laden Davie (and South Florida in general) unsuitable for most livestock. They would never have imagined its reputation as a "cow town" 50 years later. In 1950, Davie initiated weekly cattle auctions. The exterior and interior views of Huck Lyle's cattle market, adjacent to the site of the present rodeo arena, are shown here about 1952. (H2067.1 and H2067.4)

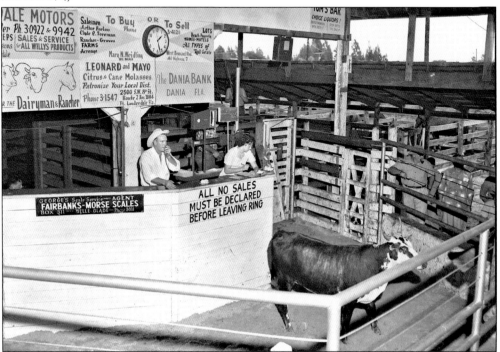

In 1915, Fort Lauderdale's Central School opened on Southeast Second Street and Third Avenue. Over the years, Fort Lauderdale High School, as it came to be known, added many wings and housed elementary, junior high, and senior high students. In 1962, a new building was constructed to the north of town. The beautiful Mediterranean Revival building fondly remembered by thousands of loyal alumni was demolished in 1970 to make way for the first of the new downtown skyscrapers. Above, high schoolers check out a jalopy in the parking lot. Below, high school and junior high students exit the middle of campus, around the early 1950s. (H47802.2 and H342.7)

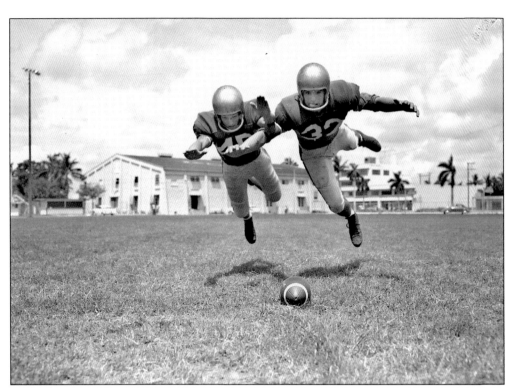

By the late 1910s, Fort Lauderdale High's track team had earned the student body a unique sobriquet—the Flying Ls. Above, in September 1958, two football players seem to be living up to their nickname during practice on the high-school athletic field, at what is now the southwest corner of Federal Highway and Broward Boulevard. At right, band members and majorettes line up in full regalia on the same field in the early 1950s. Note the gymnasium in the background. (H17224.2 and H342.9)

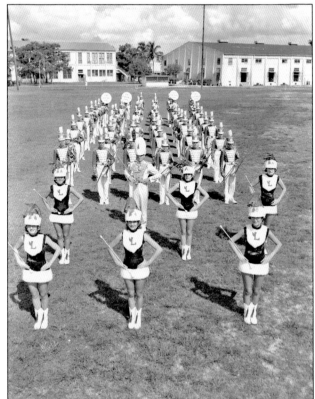

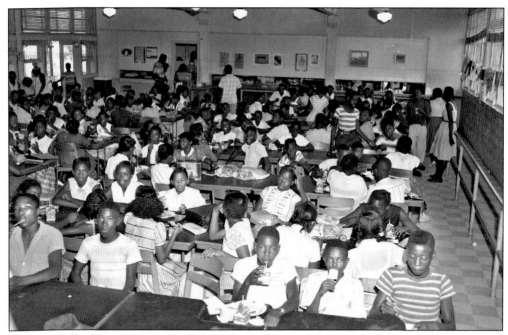

The new Dillard Junior-Senior High School, which served Fort Lauderdale's African American community, was constructed in 1952 at Northwest Eleventh Street and Twenty-sixth Avenue. Here, what looks to be the mostly junior-high crowd shares lunch in the school cafeteria about 1956. (H10393.4)

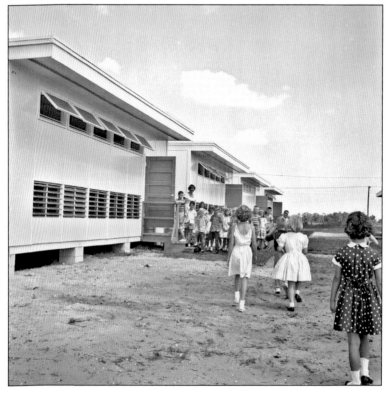

Broward County's rapidly growing population taxed the resources of the local school system in the 1960s. Here, students in the new city of Lauderhill are forced to make do with a school made of portables in 1962. (H29979.2)

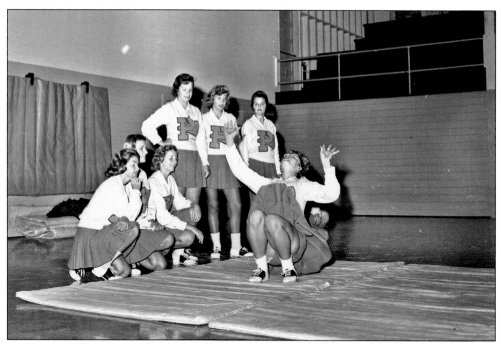

In the mid-1950s, Pompano High School moved to a new building on Northeast Sixth Street, and the former "Beanpickers" became the "Golden Tornadoes." Pompano cheerleaders practice a tricky move in the new gymnasium c. 1958. (H17416.8)

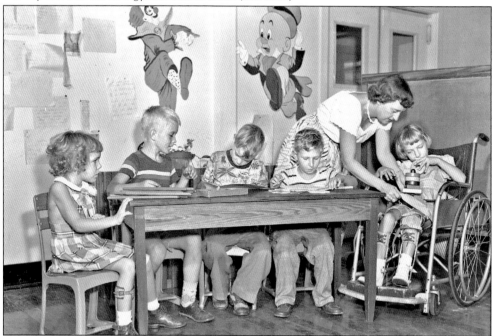

In the 1950s, children with disabilities were welcomed at the Exceptional Children's School, a special facility of the Broward County Public School system. Due to intense crowding in that system, the school was forced to meet in the old barracks of the former Naval Air Station, Fort Lauderdale, now the Fort Lauderdale Hollywood International Airport. (H225.1)

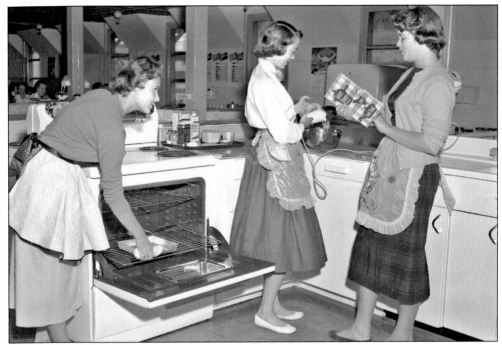

The old naval air barracks at the county airport saw a second life as the home to several schools in their formative stages. Here, early Stranahan High students whip up a recipe in home economics class, c. 1956. (H9622.1)

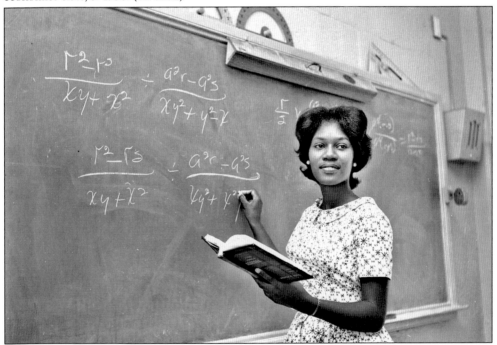

Attucks, located at 3500 North Twenty-second Avenue in Hollywood, was one of three schools serving African American students in Broward County for many years. Here, a young math teacher applies some challenging quadratic equations to the blackboard in February 1962. (H29113.3)

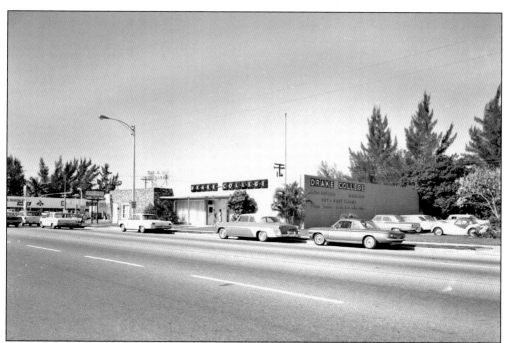

Founded in 1940 as the Walsh School of Business Science, Drake College was a small business school operating in Fort Lauderdale in the 1960s. In 1968, Gene Hyde shot a story for UPI over a controversial educational issue of the day—the length of male students' hair. Above is a shot of the benign exterior of Drake (in one of its several locations) on Northeast Fourth Avenue just north of Sunrise in March 1963. Below, an administrator points out the "Statement of Rights and Responsibilities of Students at Drake College" to a "long-hair" and (no doubt "hippy") student. (H30591.1 and H44683.1)

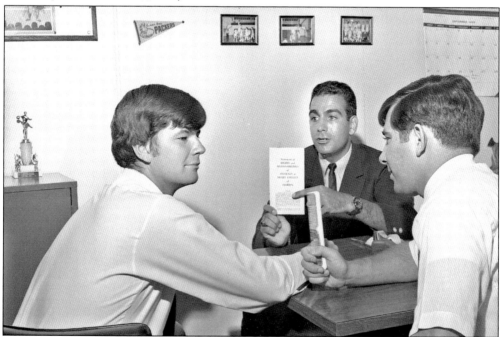

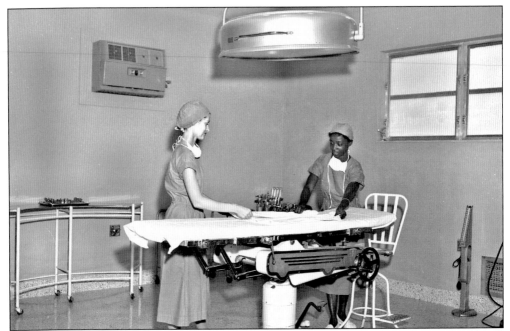

In the days of segregation, Provident Hospital, located on Sistrunk Boulevard, served the black community until the integration of Broward General in 1964. In this photo, nurses show off the operating room at Provident, c. 1957. Note the wall-mounted air-conditioner—the latest thing—at upper left. (H13458.1)

In the 1950s, the community raised $1.25 million to build Holy Cross Hospital on North Federal Highway, just south of Commercial Boulevard. This photo was taken in 1957, a little over a year after the hospital opened its doors. A closer look out the window reveals the tract of undeveloped land that was northern Fort Lauderdale in the 1950s. (H13391.6)

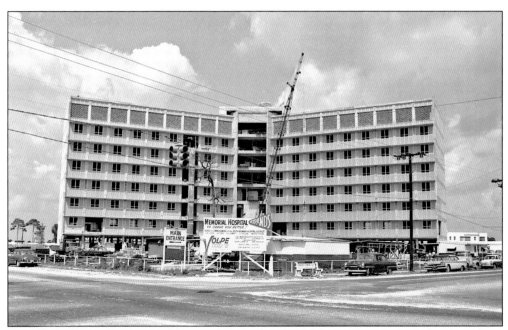

In 1953, Hollywood's Memorial Hospital opened at 3501 Johnson Street. Some local residents protested the location of the new facility as "out in the wilderness," well west of today's I-95. By 1962, the hospital was undergoing a major expansion, shown here, as was the surrounding community of Hollywood Hills. (H29265.1)

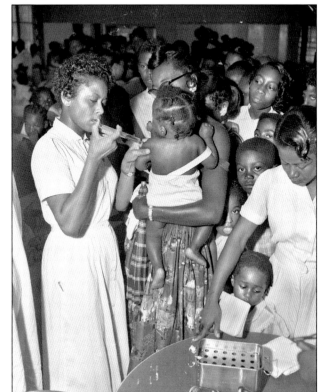

In the 1950s, polio threatened American youngsters with paralysis and the possibility of life in an iron lung. By 1955, Jonas Salk's vaccine was given to schoolchildren around the country in a series of three injections. Here, health department nurses administer the vaccine to no doubt timorous recipients somewhere in Broward in about 1956. (H10892.3)

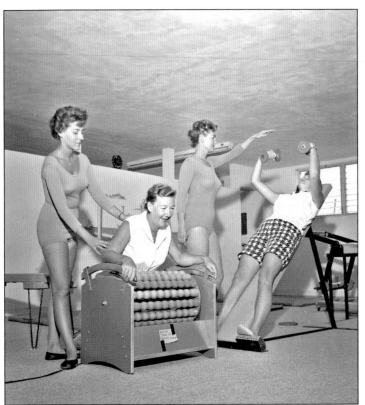

There's nothing new about women going to "the gym." At the Christensen Health Salon and Gym at 2741 Hollywood Boulevard, two clients receive "personal training" 1959 style. (H19177.3)

Fort Lauderdale's longtime tennis instructor, Jimmy Evert, served the Parks and Recreation Department from 1948 through 1997. Under his guidance, Fort Lauderdale's tennis program would become one of the most respected in the country. Here he poses with a nighttime class at the clay courts at Southside (now Hardy) Park, c. 1956. (H11438.3)

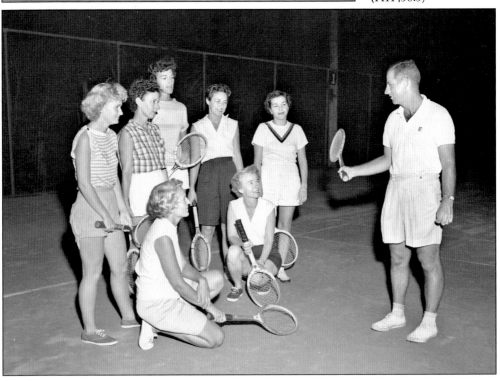

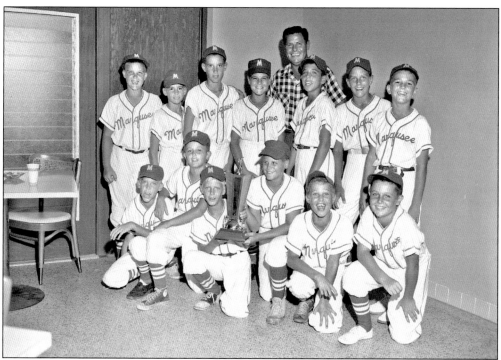

Little league teams flourished in the Broward County of the 1950s. Above, Margate developer Jack Marqusee's sponsored team poses with a shiny new trophy in 1958. Below, in 1956, the Wilton Manor Optimists' team goes to bat in the still rustic fields of that young city. (H16911.1 and H10488.2)

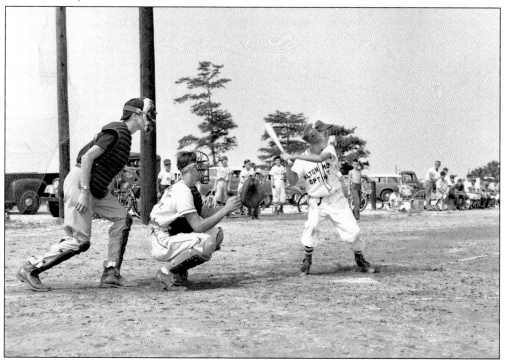

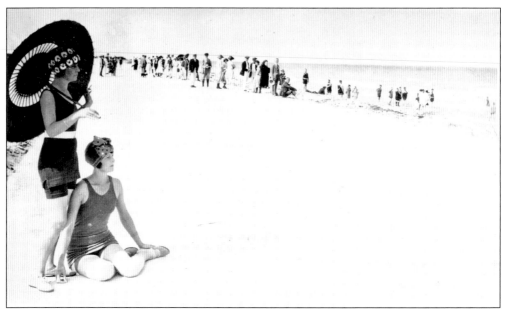

Above, an unidentified photographer documented Hollywood's "Broadwalk," resplendent with well-posed bathing beauties, for a promotional postcard in the mid-1920s. In 1959, photographer Gene Hyde mimicked that same scene with an assignment he recorded as "old time story." (5-20,620 and H19579A.1)

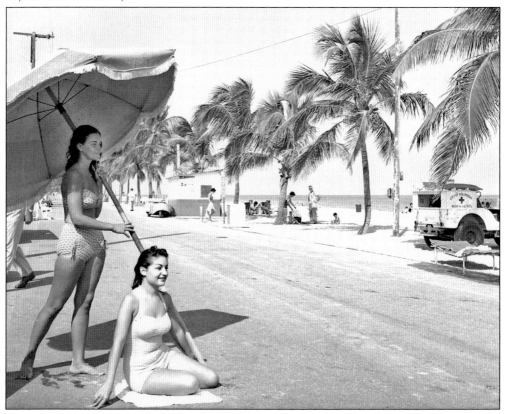

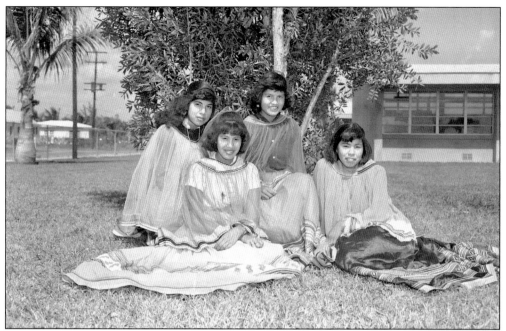

In 1956, Seminole beauty queens pose in the latest in Seminole fashion—patchwork skirts and sheer capelets over modern blouses. Maydell Osceola, Dorothy Tommie, Priscilla Doctor, and Judy Bill Osceola were all contenders for the title of queen of the first Seminole tribal rodeo, held in 1956. They were also students at Olsen Junior High School in Dania, visible in the background. (H9655.1B)

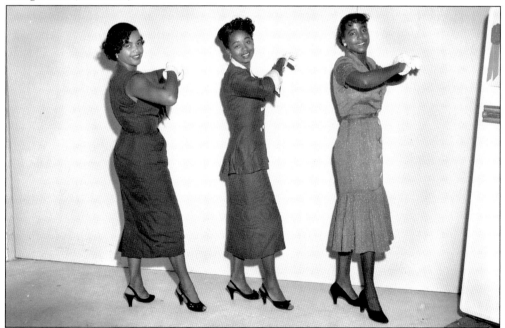

In the 1950s, "charm schools" preached fashion sense, poise, and etiquette to young American women. Here, three young ladies pose in fabulous 1950s attire at a Fort Lauderdale charm school in 1955. (H7952.2)

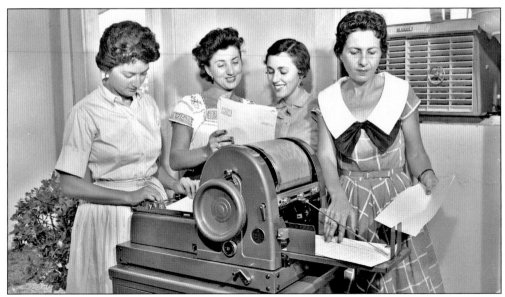

In his years as a photographer, Gene Hyde unwittingly documented the amazing advances in technology enjoyed by the residents of Broward County from the 1930s through the 1970s. Above, members at Temple Emanu-El, then located on South Andrews Avenue in Fort Lauderdale, crank out the congregation's newsletter on the latest in printing technology—a mimeograph machine—in 1957. (Don't miss the new window-mounted air-conditioner, either.) Less than 20 years later, staff members at Atlantic Bank (below) check out accounts at a 3270 terminal for an IBM 370 mainframe computer. (H13100.1 and H47772A.1)

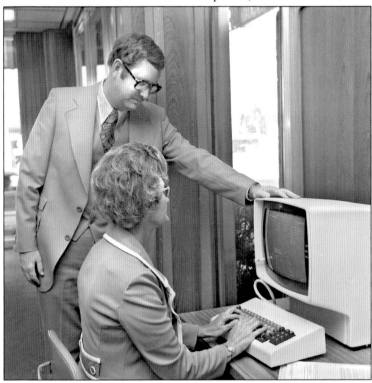

Two

THE NOT-SO-EVERYDAY

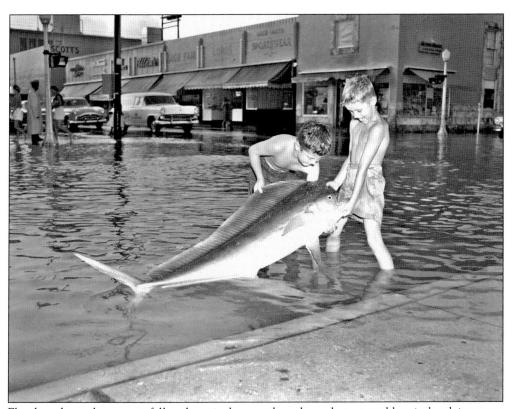

Flooding due to heavy rainfall and tropical storms has always been a problem in low-lying parts of Broward County, where the highest altitude is 35 feet above sea level. In 1953, yet another storm caused waterways to flow in the streets of downtown Fort Lauderdale. Two boys gleefully recover a "fish" from the storm drain on Southeast First Avenue and Second Street (probably with the assistance of Reese Taxidermy). (H47804.1)

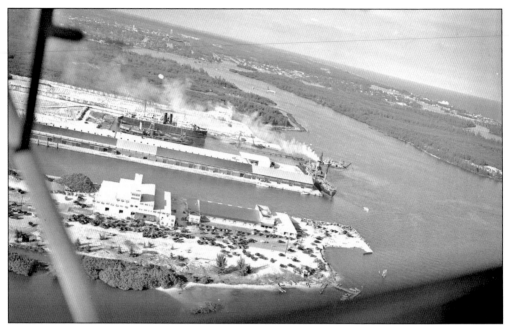

In December 1939, Broward Countians were pulled into events an ocean away when the German freighter *Arauca* sought sanctuary at Port Everglades from the British cruiser *Orion*. The federal government interned the *Arauca* and her crew at the port. Here, Gene Hyde captures an aerial look at the temporary tourist attraction in about 1939; the small ship is at the center left of the photo. (H15.2)

In March 1941, President Roosevelt paid a visit to Fort Lauderdale, arriving for a stay aboard his yacht, *Potomac*. On March 30, he gave his approval for the seizure of all German ships in American ports. Gene captured this foreboding scene of the *Potomac* as it passed the docked *Arauca* at the port. (H15.7)

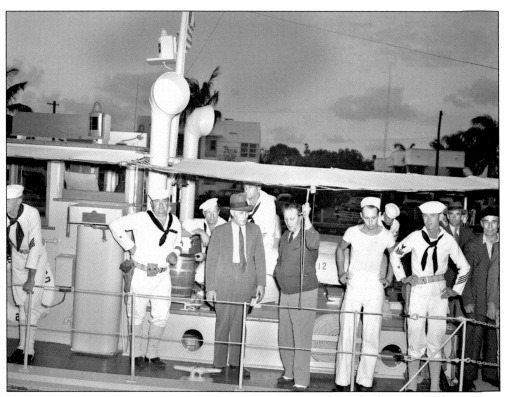

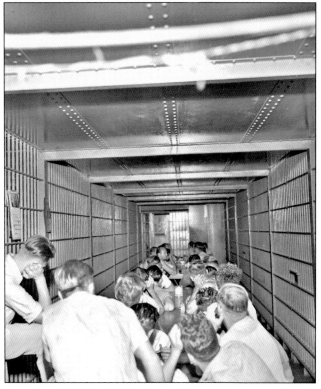

For the first year of their interment, the *Arauca* captain and officers were allowed freedom in the town and actually struck up friendships with local officials and port managers. On April 1, 1941, captain and crew were removed to the Coast Guard base and later the Broward County jail, where they were held on the technical charge of violating U.S. immigration laws. They were later transferred to Ellis Island and repatriated after the war. Above, Guardsmen surround the *Arauca* crewmen on the trip to the Broward County jail (in the courthouse). At left, disgruntled *Arauca* crewmen eschew publicity from their jail cell. (H15.6 and H20.7)

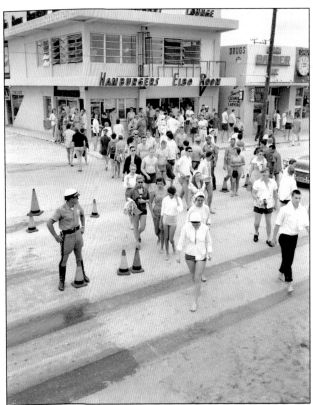

Fort Lauderdale was already established as a retreat for the collegiate crowd by the 1950s. In 1953, city leaders actually issued an invitation to colleges throughout the nation. In 1954, *Holiday* magazine named Fort Lauderdale "the greatest college town in the country." Spring break central was the Elbo Room, a bar located at the corner of Las Olas and A1A. Above, students pour out of the lounge under the watchful eye of the police in 1958. Below is a rare picture of the same crowd, inside the lounge. Hey—this is "where the boys are." (H16149.6 and H16149.5)

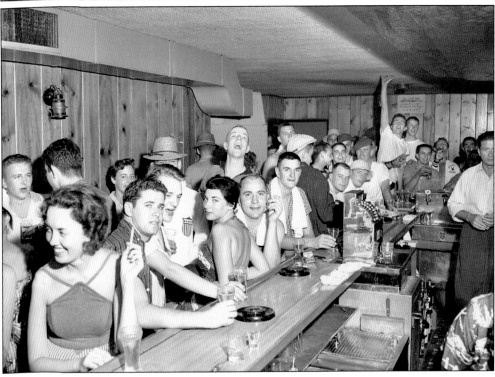

Despite the boon to the local economy from the annual ritual, the students were notoriously thrifty— cramming as many people into crowded quarters as possible. At right, young ladies take a break from the sun at the swanky Marlin Beach Hotel in 1959. Note the period television and air conditioner amidst the mess. Below, the guys get in some rest in an unidentified hostelry, c. 1954. (H18534.5 and H4158.1)

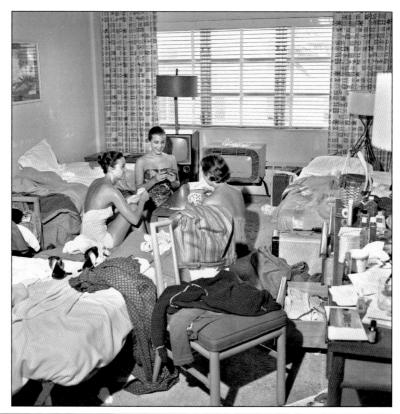

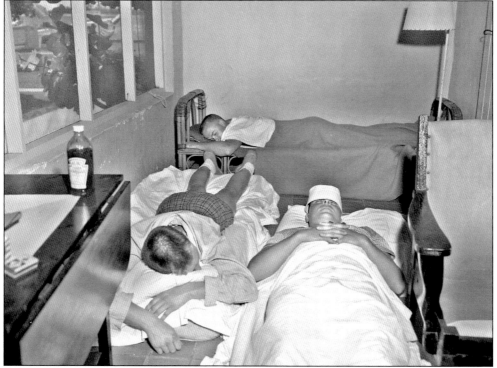

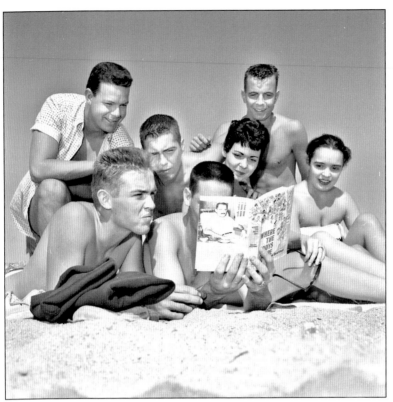

In 1959, *Time* magazine reported a coed's reason for coming to Fort Lauderdale: "This is where the boys are." English professor Glendon Swarthout lost no time in producing a novel of the same name. By 1960, the film version was in production on the Fort Lauderdale beach. At left, students check out the novel beachside. Below, the cameras are rolling in front of the Elbo Room in 1960. (H20077.5 and H21975.5)

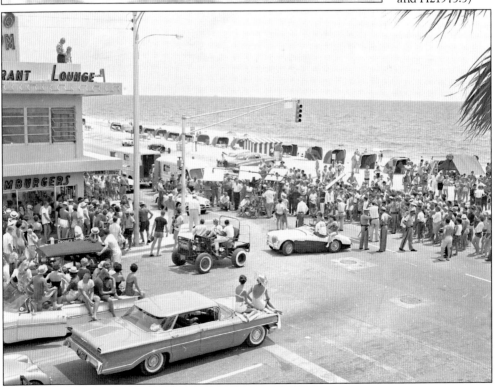

Where the Boys Are premiered at Fort Lauderdale's Gateway Theatre (which still stands on Sunrise Boulevard) on December 21, 1960. Three months later, the crowd of 10,000 spring breakers grew to 50,000—and the city was aghast. Above, the marquee of the Gateway announces an important world premiere. Below, the stars line up on the Gateway's stage. From left to right are Chill Wills, Fort Lauderdale Mayor Howard H. Johns, producer Joe Pasternak, Frank Gorshin, Maggie Pierce, Paula Prentiss, and Jim Hutton. (H21975.7 and H21975.3)

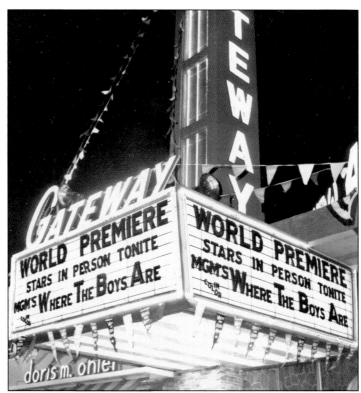

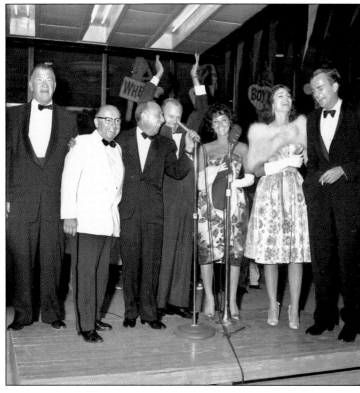

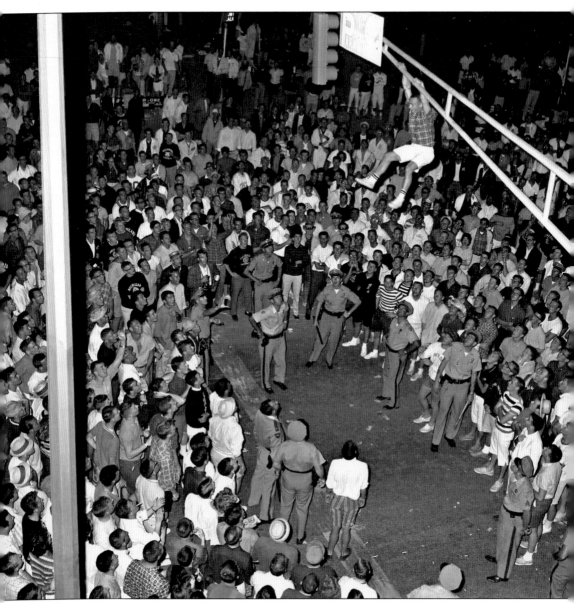

One of the most infamous of spring break "incidents" occurred in 1961, when student George Dalluge climbed the traffic light at Las Olas and A1A. There he (possibly under the influence) encouraged the drunken crowd to make demands of the city, such as allowing alcohol on the street. He was eventually sentenced to 70 days in jail. Gene Hyde was there to capture this shot, which was picked up by *Life* magazine, appearing as a centerfold—probably Gene's most famous photograph. (H22606.12)

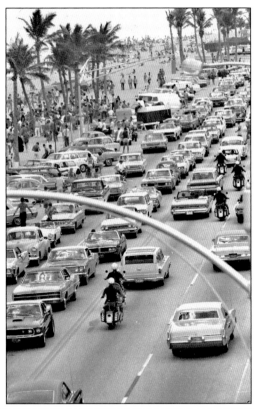

The annual invasion that was spring break continued to grow throughout the 1960s, 1970s, and 1980s. By 1985, crowds reached an estimated 350,000 students. While the visitors contributed as much as $120 million to the local economy, local leaders felt that the costs had come to outweigh the gains and began to initiate measures to encourage students to seek other venues. At right, the mad crush that was traffic on "the strip" is seen in 1969. Below, the mad crush of pedestrian traffic at the street crossing by the Elbo Room is seen in the same year. (H47793.10 and H 47793.23)

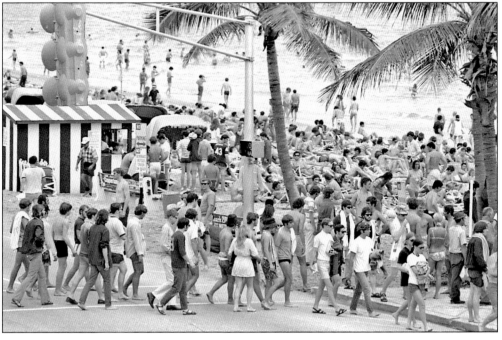

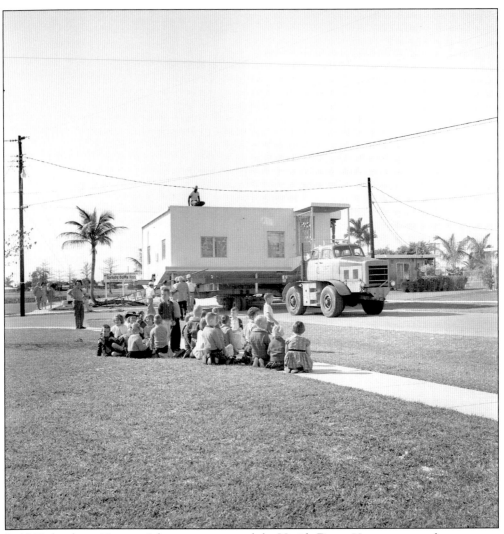

In 1960, developer Norman Johnson constructed the Upside Down House as a novelty to attract prospective buyers to his new residential golf community on Sunrise Boulevard west of State Road 7. In 1961, the community became Sunrise Golf Village—incorporated in 1971 as the city of Sunrise. The Upside Down House, complete with upside-down interior and car in the carport, rested upon at least three locations before its eventual demolition. Here local students watch with wonder as movers truck the house to a new location in the 5900 block of Northwest Fourteenth Place in February 1964. (H42328.1)

One of the most controversial issues in the history of Fort Lauderdale was the Federal Highway Tunnel under New River. Gene Hyde documented the entire construction project with hundreds of photographs from the ground and the air. This image shows a partially completed tunnel in March 1960 in front of the Pioneer House restaurant, now the Stranahan House museum and, ironically, the place where the original ferry crossing once stood. (H22636.2)

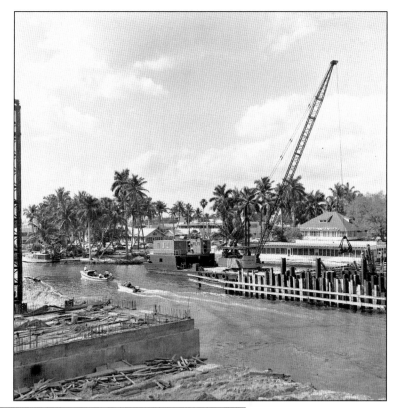

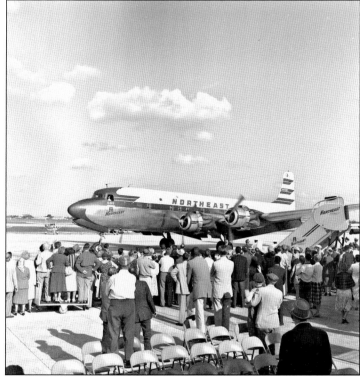

After World War II, the Broward County government acquired the former Fort Lauderdale Naval Air Station from the federal government and began to develop its aviation facilities there. In the early days, it achieved success as a general aviation hub, serving primarily business operations. In 1953, Mackey Airlines began service to the islands, and in 1958, 1,500 people greeted the first Northeast Airline flight from New York to the future Fort Lauderdale/ Hollywood International Airport. (H17764.1)

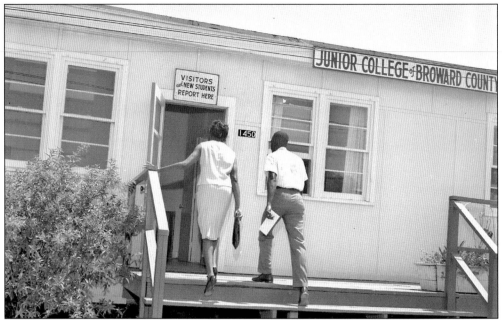

In the 1960s, the local NAACP and other activists began to bring the fight for integration of public facilities to Broward County in earnest. Here, in 1961, Gene Hyde records the first African American applicants at the new Junior College of Broward County (today's Broward Community College), located in the former buildings of the naval air station at the airport. (H27750.1)

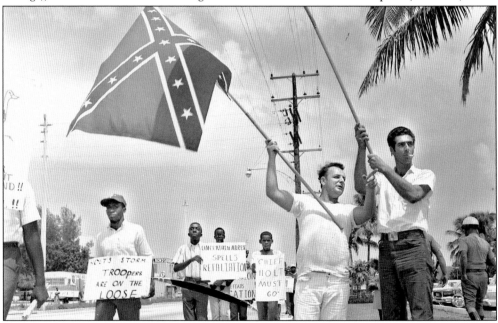

In the summer of 1966, conditions were rife for racial unrest as riots shook major American cities. In August, a group of African American youths were arrested for throwing rocks and bottles at police cruisers. Local black leaders charged the Fort Lauderdale police with harassment and cruel conditions and organized the protest march at the police station shown here. Charges against the young men were later dropped. (H43442.29)

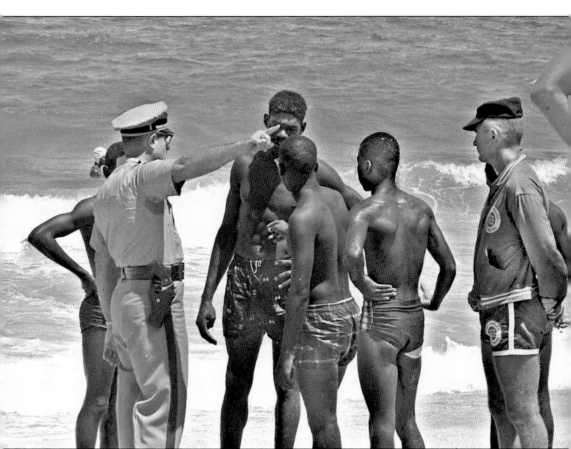

In the summer of 1961, Eula Johnson, Von D. Mizell, and the NAACP launched a series of "wade-ins" at Fort Lauderdale's "whites only" beach. The purpose was not initially integration, but to force county commissioners to provide access in the form of a causeway to the county's "black beach," located on land just south of the port in today's John U. Lloyd Park. Gene Hyde snapped what is probably now his most-used photograph in August 1961—truly proof that a picture speaks a thousand words. (H28152.12)

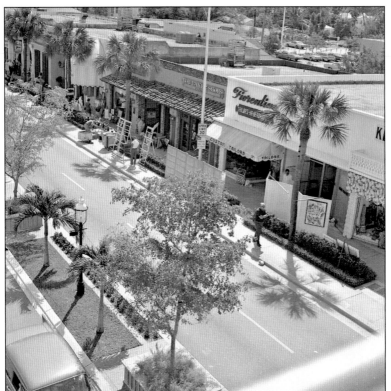

What is today one of Fort Lauderdale's major attractions, Las Olas Boulevard, began its rise as an upscale shopping district in the 1950s. By 1970, major improvements created a beautifully landscaped corridor, home to unique shops and the well-known Las Olas Art Festival, shown in progress in that year. (H47780B.2)

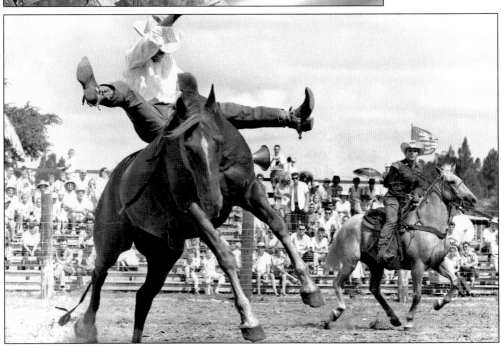

In somewhat of a contrast to "uptown doin's," Davie was well known for its annual rodeo, held on the same spot since World War II. Here a cowboy performs a difficult gymnastic move aboard a bucking bronco in 1956. (H9283.15)

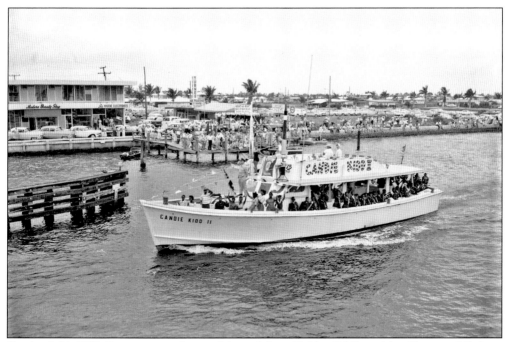

On April 14, 1958, Pompano residents celebrated their Golden Jubilee with a "boatacade" along the Intracoastal. Here the *Candie Kidd II* passes the "reviewing stand" and happy onlookers near the Atlantic Boulevard bridge. (H16190.1)

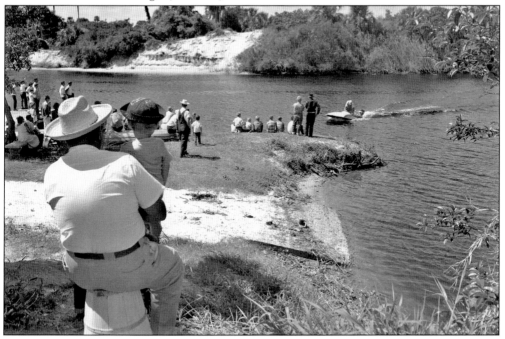

In 1947, the city of Deerfield completed its Pioneer Park on the Hillsboro Canal and began an annual festival to celebrate the city's past called Cracker Day (now Founders Day). Here, in 1957, young and old attend a waterborne demonstration in the canal that divides Broward from Palm Beach County. (H13330.3)

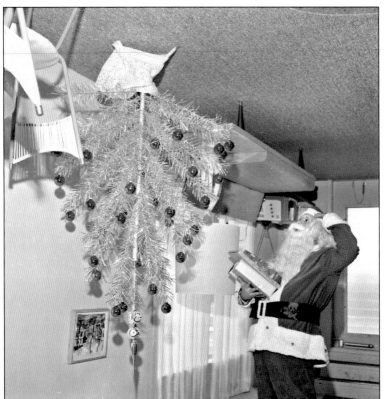

Developer Norman Johnson's Upside Down House was a gimmicky draw to a new residential development off west Sunrise Boulevard in what is today the city of Sunrise. Here Santa Claus pays a perplexed visit to the property in its first location at 6021 Northwest Twelfth Court in December 1960. (H21949.1)

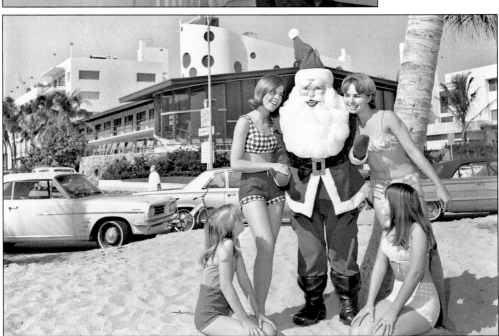

Young models fawn over a somewhat plastic Santa in an apparent publicity shot Gene took on the beach in front of the Jolly Roger Hotel at the north end of Fort Lauderdale's strip in April 1967. (H43997.3)

Here young Seminole children from the nearby Hollywood Reservation are greeted by Santa in an event held in a local hotel in December 1963. (H41999.3)

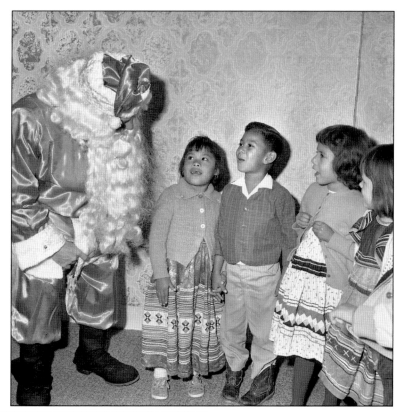

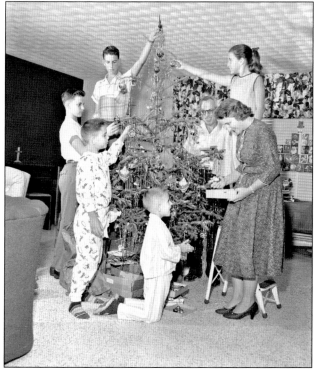

Gene Hyde captured this portrait of Broward-style Christmas in 1955. Notice the new terrazzo floor, swirled ceiling, and rather bold draperies characteristic of one of the thousands of new homes constructed here in the 1950s. Even the Christmas tree bespeaks its era—perhaps a little sparse by modern standards, but certainly well bejeweled. (H8906.1)

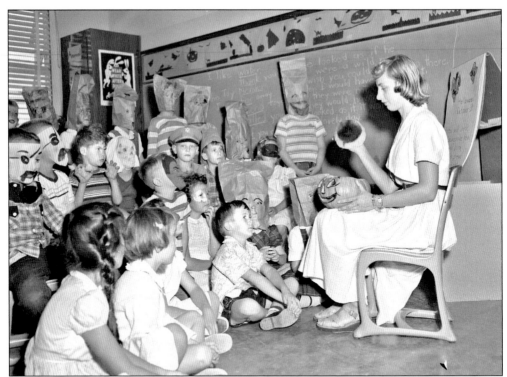

Halloween was a very special time for area students in the 1950s. Schools sponsored fairs and haunted houses, and classrooms enjoyed costume contests and parties with lots of treats. Above, a young teacher reveals the secret of a jack-o'-lantern to some rather eerily costumed children at the new Croissant Park Elementary School at 1800 Southwest Fourth Avenue in Fort Lauderdale, shown below in October 1952. (H240.1 and H223.1)

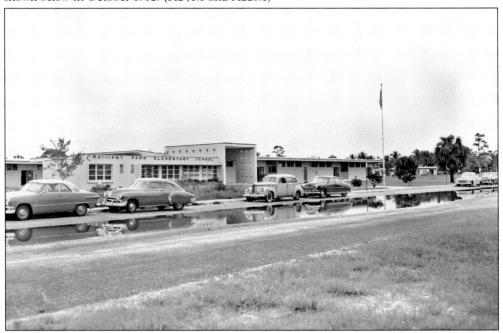

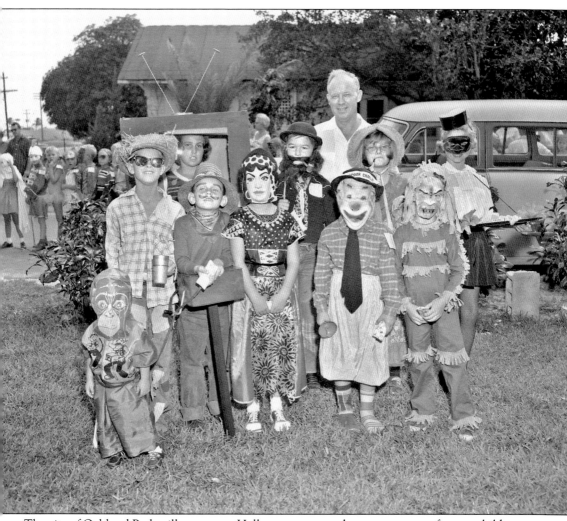

The city of Oakland Park still sponsors a Halloween party and costume contest for area children at its public facilities. This 1956 motley crew of prizewinners include such timely costumes as a "cigarette girl," what looks to be the Creature from the Black Lagoon, Mammy Yokum, and a television set. (H11676.1)

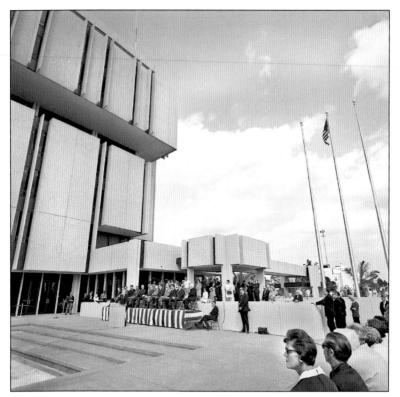

By the end of the 1960s, one of America's fastest growing cities, Fort Lauderdale, Florida, found the need for yet another new city hall. The current structure was designed by architects William Parrish Plumb and Robin John in what was then a distinctly modern and untraditional style. In this view, local officials await their turn to speak at the dedication of the new facility on February 23, 1969. (H44847.1)

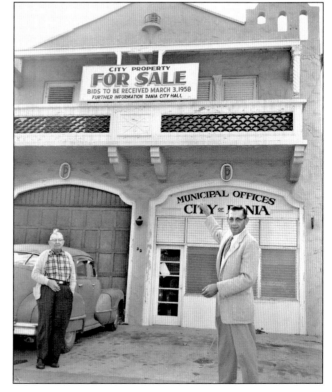

Until the 1950s, this diminutive building located at 22 South Federal Highway served as Dania's city hall. The fire truck was housed on the ground floor along with the city clerk and, on the north side, the police office. The firemen's bunks occupied the second floor. By 1958, a newer, grander facility was built, and the little building was put up for sale. Here Mayor Frank Eby makes a sale pitch to the photographer. (H15687.1)

The 1960 presidential campaign—the first in which the magical new medium of television played a serious role—captured the rapt attention of Broward County residents. At right, the local Kennedy/Johnson hardcore gather for a rousing Democratic song. (Interestingly, Broward went Republican, casting 68,294 votes for Nixon versus 47,811 for Kennedy.) Below, a poll worker at a Dania fire station monitors a "new fangled" voting machine. (H21622.4 and H21560.3)

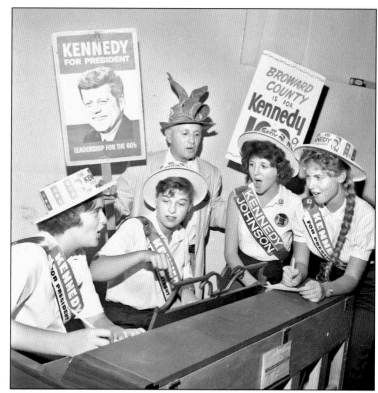

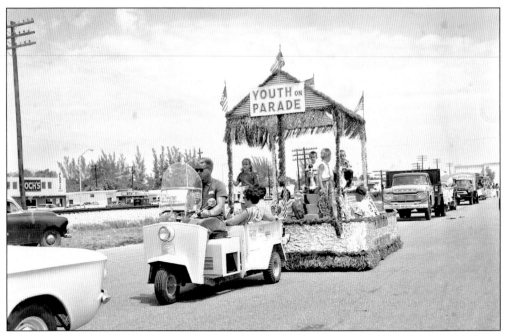

Oakland Park's Youth Day activities have been held annually during the public school system's spring vacation time since the 1950s. The height of the festivities is the parade, which travels through local neighborhoods and down Dixie Highway at the heart of town. In 1961, sister city Fort Lauderdale joins the fun with this float created by the recreation department. (H27673.2)

The town of Davie's Orange Blossom Festival began in 1940 as a celebration of the spring orange harvest. A parade, rodeo, and other activities still feature local merchants, farmers, and growers. Here children promenade on Davie Road and Orange Drive in the preferred Davie style: using "horse" power. (H9283.35)

The city of Fort Lauderdale's Recreation Department highlighted its 1950s summertime youth activities with an annual Playground Parade. In 1955, America's fascination with science fiction and the not-so-fictional cold war race for space was celebrated with a "space parade" theme. Above, some remarkably realistic looking satellites march along Broward Boulevard at Southeast First Avenue, beside the shuffleboard courts that once graced Stranahan Park. Below, some "beauty queens of the future" parade with their presumed future transport in the 100 block of Southeast First Avenue, just east of what is now the main library. (H7827A.3 and H7287A.4)

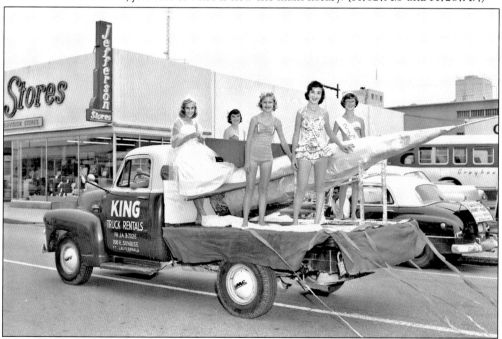

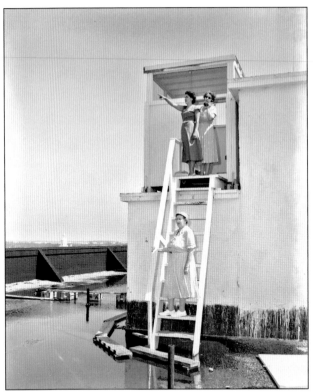

In the 1950s, long before the Cuban Missile Crisis, a growing concern for civil defense resulted in the reactivation of the aircraft observation system last used in World War II. "Zero point" for Broward County was the Sweet Building (the closest thing to a skyscraper in the whole county), where three veteran observers pose c. 1953. Note the county courthouse spire at the left. (H1289.1)

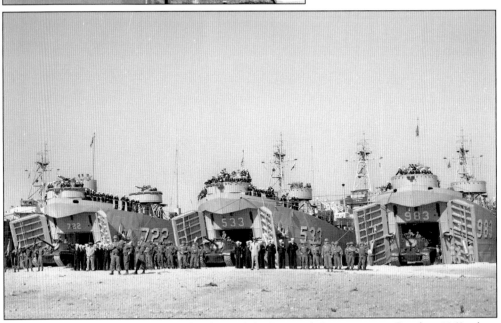

The fears of the cold war era were heightened for Broward Countians in October 1962 when Port Everglades hosted both army and navy troops as a potential staging area for military action during the Cuban Missile Crisis. Fortunately by December 1962, tensions had eased and the troops sent home. Here, some rather imposing-looking naval landing craft line up for a farewell thank-you ceremony. (H40312.2)

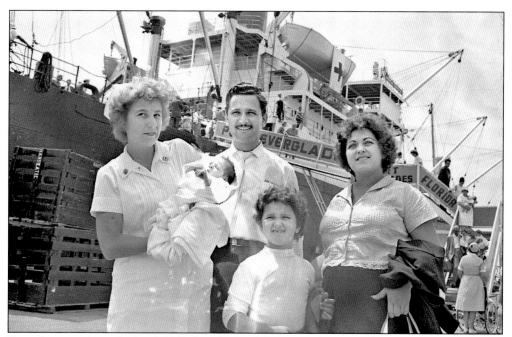

From January through April 1963, hundreds of Cuban exiles escaped Castro's regime on Red Cross–sponsored ships, landing initially at Port Everglades. Here a Red Cross nurse poses with a grateful young family in front of their ticket to freedom, the *Santo Cerro*. (H41029.14)

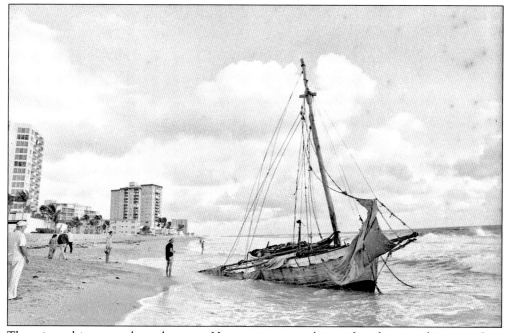

There is nothing new about desperate Haitian citizens seeking refuge from conditions in their native land. This small boat, crowded with 65 political refugees, came ashore off the Jade Beach East condominium in Pompano Beach on December 12, 1972. The residents there shared food, coffee, and blankets with the escapees until immigration officials arrived to bus them to Miami for processing. (H46519.12)

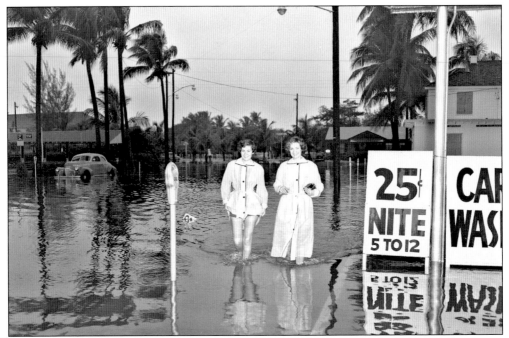

The flooded streets of downtown Fort Lauderdale afford an irresistible opportunity to two young ladies on Southeast First Avenue in 1953. A rather underdeveloped Broward Boulevard is visible in the background. (2179.4)

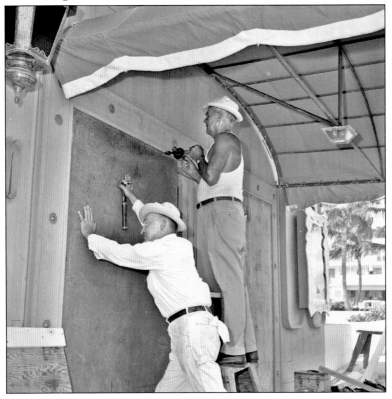

During the 1960s, Broward residents unfortunately became well practiced at battening the hatches as three hurricanes affected the area. Here, in 1960, two Gill Construction workers secure the door at a Fort Lauderdale beach hotel before Hurricane Donna. (H21443.7)

Three

THE COUNTY GROWS

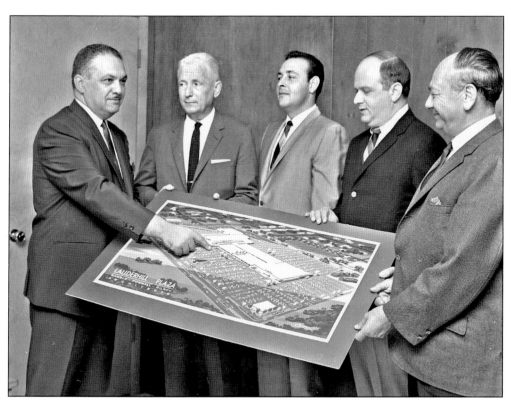

The city of Lauderhill is today known as the "crossroads of Broward County" because of its central location and diverse population. The city was incorporated in 1959, not long after developer Herb Sadkin built model homes on Northwest Twelfth Street on former McArthur Dairy lands. In this c. 1965 photo, Sadkin (at left) and fellow developers look at the plans for the Lauderhill Mall, an enterprise that initiated the development of the State Road 7 corridor north of Sunrise Boulevard. (H43023.2)

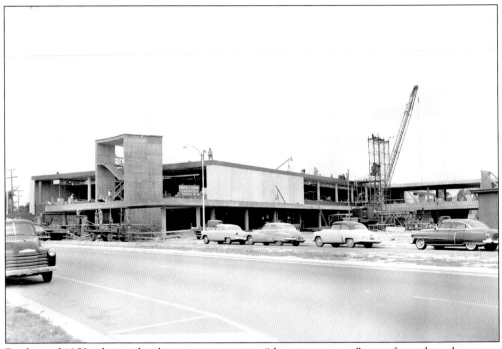

By the mid-1950s, daring developers were opening "shopping centers" away from the urban core, amidst the growing suburbs of Broward County—a trend that was to eventually lead to the near-demise of the county's downtowns. In 1955, the trendy Searstown shopping center was constructed in Fort Lauderdale at the curve of Federal Highway where it jogs onto Sunrise Boulevard. The above photo shows Searstown under construction c. 1955; the photo below shows a shopping frenzy in the interior shortly after opening. (H6332.5 and H356.2)

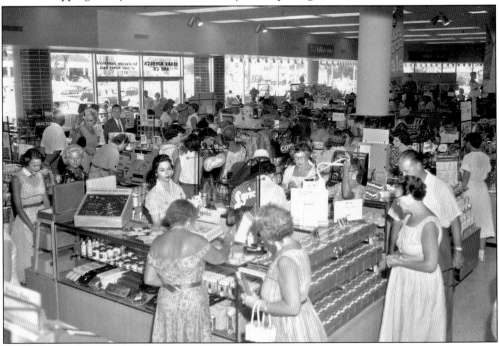

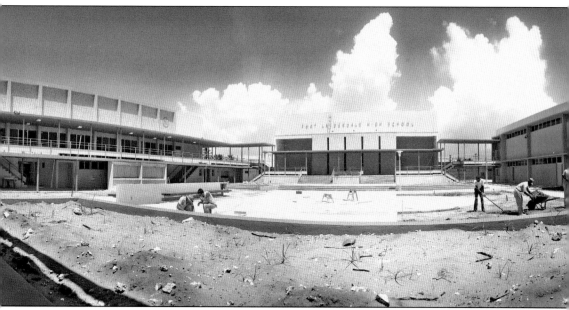

In 1962, Fort Lauderdale High School made a radical move from downtown north to the Wilton Manors line, on Northeast Fourth Avenue. The new structure was the first fully air-conditioned high school in the state, costing $1.7 million. In this wide-eye view, Gene Hyde documents the finishing touches in August 1962. (H29825.12)

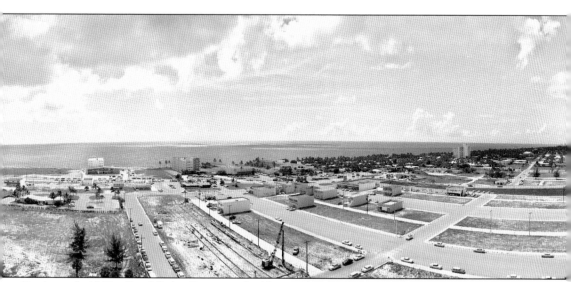

By the early 1960s, Coral Ridge Properties had begun the development of the area north of Fort Lauderdale beach called the Galt Ocean Mile after pioneer investor Arthur Galt. This wide-eye shot reveals the panoramic ocean view to be had from the as-yet-unfinished Coral Ridge Towers (I) high rise in 1962. The wide road at the center is Oakland Park Boulevard. (H29827.3)

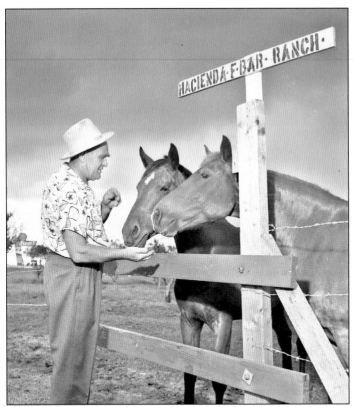

One of Broward County's most diminutive and rustic municipalities was Hacienda Village. The village, about five square miles located at the crossroads of State Road 84 and State Road 7, was incorporated in 1949, boasted as many as 250 residents in its day, and was the most notorious speed trap in the county. The little town succumbed to the construction of I-595 in the 1980s. At left, in 1958, early mayor and town marshal Heinrich Feldman feeds the horses at the Hacienda F Bar Ranch. Below, the rustic Hacienda Flores Trailer Park, also shown in 1958, was home to most of the town's residents. (H16590.1 and H16590.3)

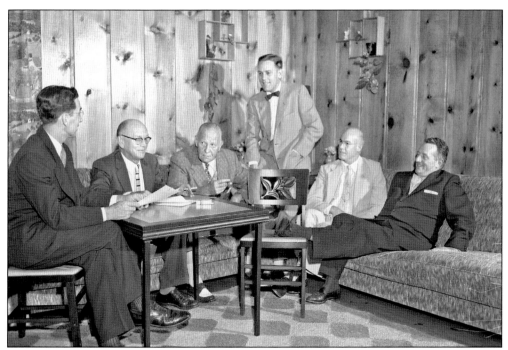

The unquestioned winner of smallest municipality in Broward County is the community known as Lazy Lake, an enclave of private homes around a former rock pit located in the midst of Wilton Manors. Lazy Lake received its charter as a village in 1952 and has averaged about 13 families on 12 acres ever since. Above, village council members gather for a meeting in January 1957. From left to right are George Roe, Mayor Charles Lindfors, Spalding Peck, Sherwood Moore, Russell Smith, and Edward Inglis. Below, the water-filled borrow pit that became Lazy Lake is shown in 1955. (H12369.4 and H8007.1)

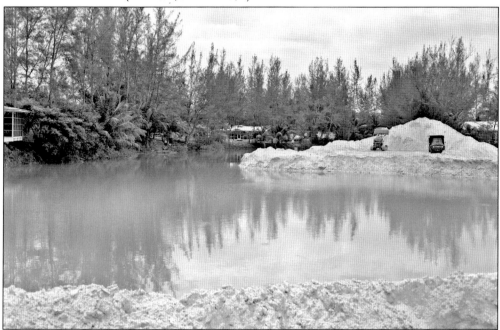

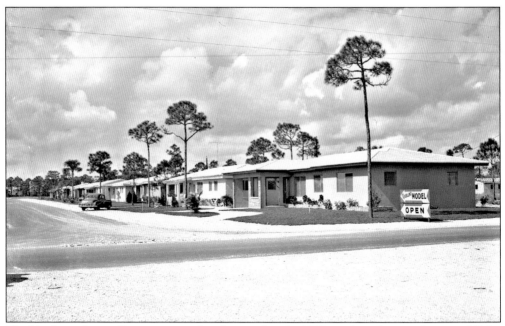

The "Andrews Avenue" extension was "on the grow" in the 1950s, and new housing began to fill the gaps between the older communities of Fort Lauderdale, Oakland Park, and Pompano. This photo from about 1952 features the early model homes of North Andrews Gardens, a large development centered around Andrews Avenue and what is now Commercial Boulevard. (H639.2)

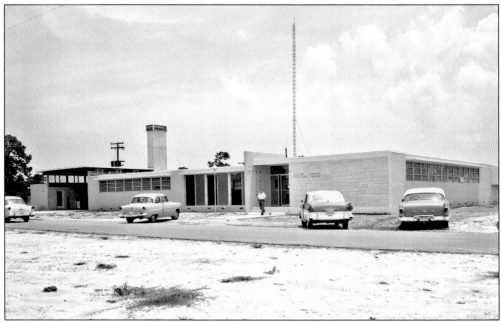

Also "on the grow" in the 1950s was the former Fort Lauderdale boom-time development of Wilton Manors. By 1947, the community was incorporated, and began to develop a separate identity, services, and stores centered along "Wilton Drive," the extension of Northeast Fourth Avenue. Here, c. 1957, Gene Hyde documents the city's second city hall, designed by Fort Lauderdale architect Bill Bigoney and still in use today, on Northeast Twenty-first Court. (H14082.2)

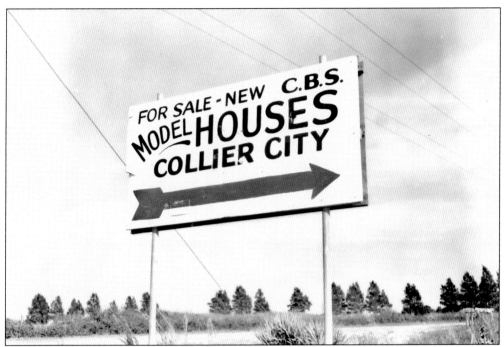

Collier City was a rustic enclave lacking paved roads and drainage and was home to many African American citizens in the northern part of the county by 1950. Developer Wade Hampton Horn, his son, and his grandson established the subdivision in 1951 on the site of a former bean farm. Today Collier City is part of the city Pompano Beach. The above photo shows a sale sign for new homes in the development and below, a family gathers outside their new cbs Collier City home in about the early 1950s. (H8554.5 and H8554.2)

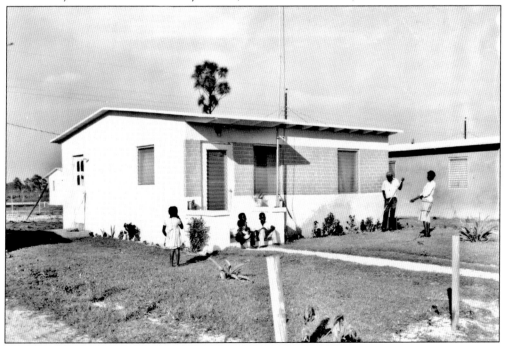

In the 1950s, a new community arose west of Hollywood, and a debate soon ensued over annexation into that city. Walter Kipnis and others campaigned to retain a separate identity for their village. In 1960, a new city named Pembroke Pines was incorporated, named for an early-20th-century farming community in west Broward and the many trees that grew in the area. Above, Mayor Walter Seth "Doc" Kipnis and finance director William Francis White stand in front of the new city hall, c. 1962. At left is a street featuring the city's namesake. (H29309.13 and H29309.19)

In November 1959, residents of the Hollywood Seminole Reservation celebrated the opening of the Seminole Estates, just west of the turnpike in Hollywood. It was the culmination of a concerted effort by the American Indians and local supporters to improve living conditions at the reservation. At right, the entrance to the new subdivision is seen, and below, Laura Mae Osceola waters the new landscaping at her new cbs home in late 1959. (H19609.1 and H19609.3)

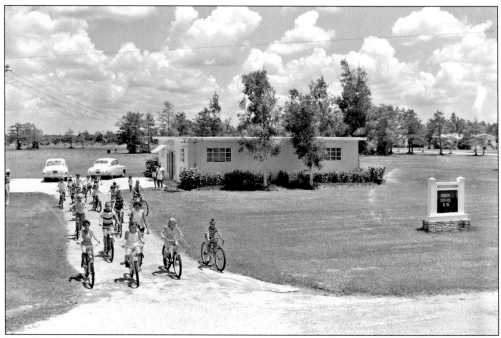

In 1953, the city of Plantation was incorporated on the site of Frederick Peters's experimental farm in central Broward County. Many of the original lots of the community were large—one acre with most of it devoted to gardens and fruits trees. Today Plantation is still the site of some of the larger lots in the county. Above, a group of young cyclists leave the Plantation Community Church at 6500 West Broward Boulevard c. 1953. Below, in the same year, a brand new home sits adjacent to the Plantation Country Club, which quickly became the social center of the community. (H311.9 and H311.6)

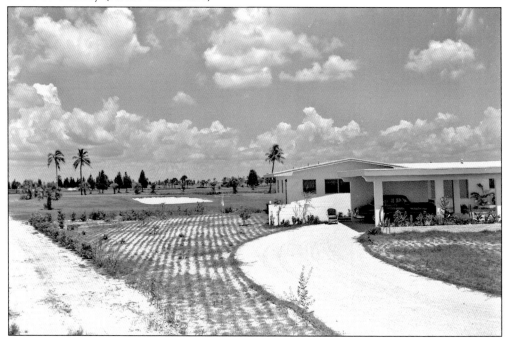

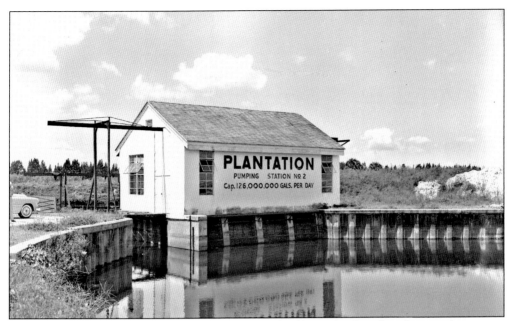

As early as 1911, an irrigation and drainage district had been developed in the area that is now the city of Plantation—necessary in a part of the county that had formerly been largely under water. Pumping station number two of the Old Plantation Water Control District, shown here in 1953, can still be found on the canal separating Seminole Park and Pop Travers field, south of Peters Road. (H311.10)

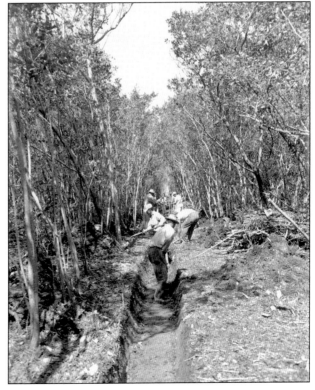

Pivotal to the development of areas away from the coast in Broward County was improved pest control. Mosquitoes, sand flies, horseflies, and other pests naturally flourished in the former swampy inland areas. Here, in the mid-1950s, workers dig "mosquito ditches" in the central part of Broward County; these were channels to drain the local marshes where these insects bred. (H7352.3)

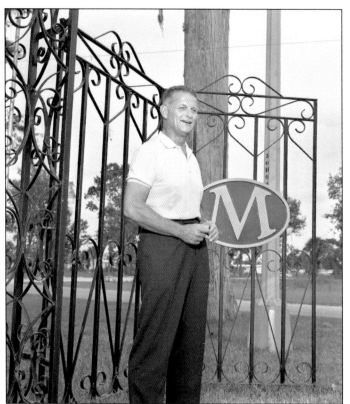

In the mid-1950s, developer Jack Marqusee acquired 1,700 acres of cow pasture and palmetto patch west of Pompano. Slowly, suburban pioneers built up a community there. They named their new town Margate after the first letters of the developer's name and the large iron gates he constructed at the entrance to the new community on Margate Boulevard near State Road 7. Today Margate serves as the gateway to western Broward. At left, Jack Marqusee poses at the gates of Margate in 1959. Below, Marqusee walks the Margate (proposed) business district along Margate Boulevard with Mrs. Fort Lauderdale 1957, Mrs. Sue Eck. (H18609.2 and H13230.10)

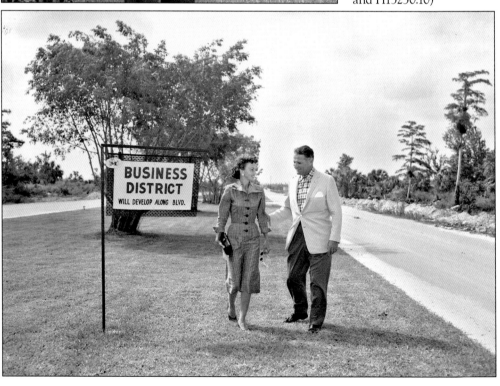

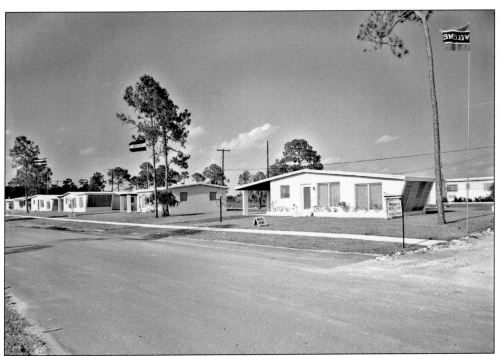

Margate's new homes, shown above in 1957, were small and sturdily built cbs structures with the asymmetry common in mid-20th-century local architecture. One feature was the use of the now much maligned jalousie windows, which were considered excellent protection against tropical storms and ideal for cross ventilation. Below "Mrs. Fort Lauderdale" observes the swanky full-length cantilevered jalousies in a model home, c. 1957. (H13230.6 and H13230.15)

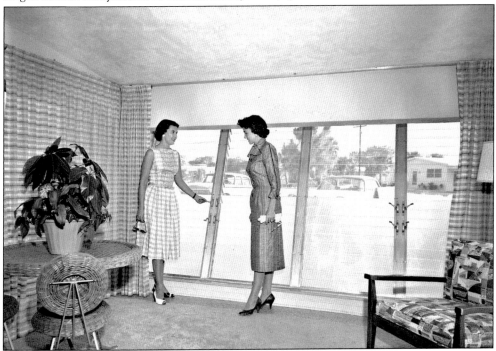

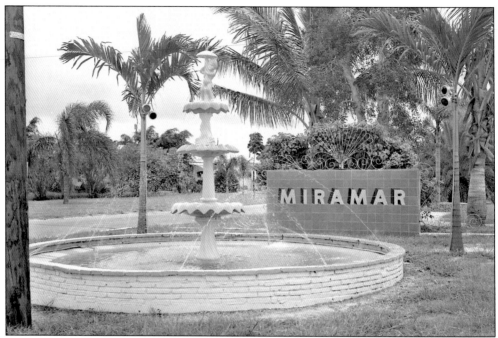

The city of Miramar was established on the site of former dairy lands in the far southern end of Broward County in the mid-1950s. Although named "look to the sea," the landlocked community served originally as a convenient bedroom community for Miami to the south and Fort Lauderdale to the north. Above, the fountain at the original entrance to the city still stands—in a modified form—at Sixty-fourth Avenue and the Miramar Parkway. Below, rows of cbs homes typical of 1960s suburban South Florida living stretch endlessly in the view from the Sunshine State Turnpike in Miramar, c. 1961. (H28100.10 and H28100.2)

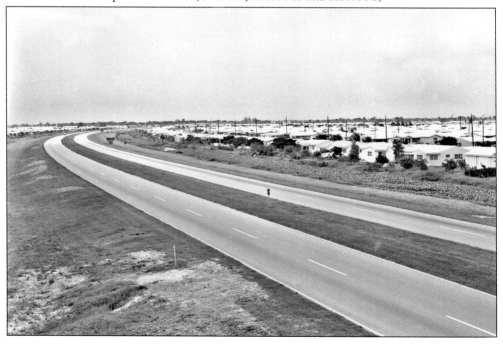

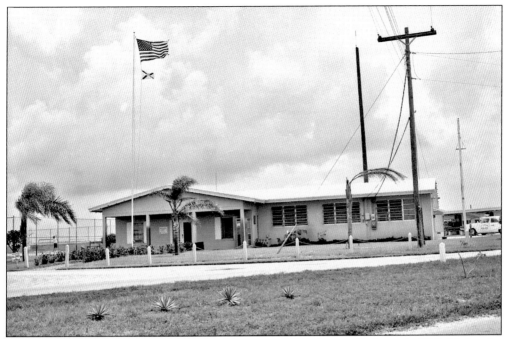

Miramar's city hall occupied this modified home at 6700 Miramar Parkway in 1961. Today the building still stands adjacent to the second city hall and is home to the Calhoun Center and the city's community services. (H28100.16)

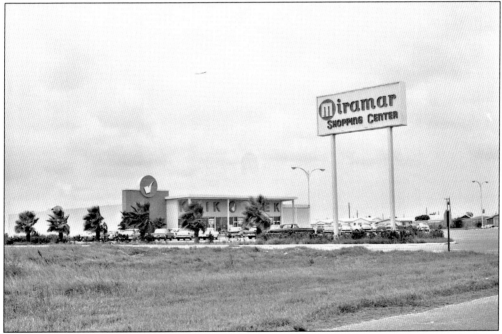

Essential to the growth of the new suburban Broward communities were convenient facilities and services being constructed well away from the traditional "downtowns" in the county's older cities. Here a lone "supermarket" belies the large sign advertising the new Miramar Shopping Center located at 6800 Miramar Parkway—still in the planning stages—in 1961. (H28100.14)

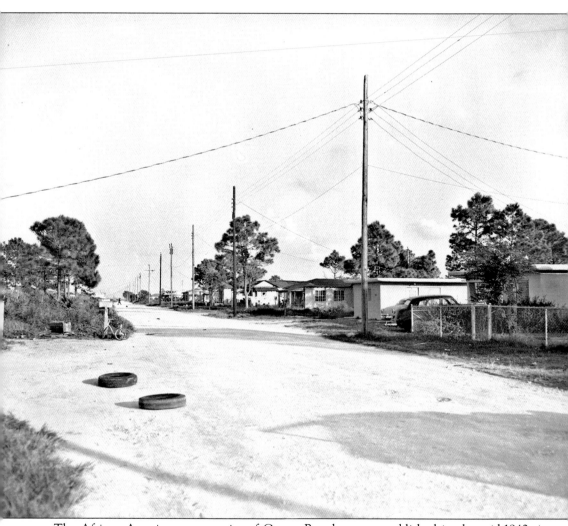

The African American community of Carver Ranches was established in the mid-1940s in west Broward between Miramar and Pembroke Park. Many of the original residents were Bahamian immigrants. For many years, the unincorporated area remained primitive by county standards with unpaved streets, well water, one mailbox, and one pay phone for the whole area. In November 2004, Carver Ranches joined with surrounding communities to form the county's newest city, West Park. This photo shows a rustic street scene in Carver Ranches about 1958. (H17806.3)

Four

WHO'S WHO?

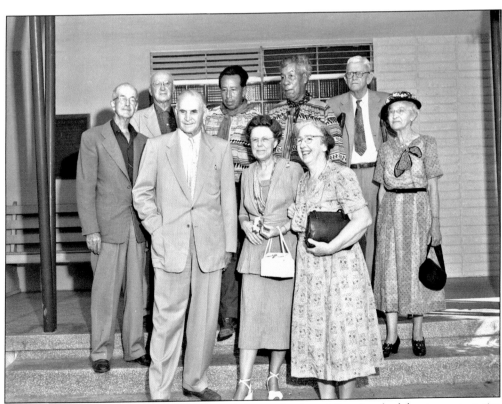

In the early 1950s, Gene Hyde documented this gathering of Fort Lauderdale pioneers at city hall, which was then located at 300 North Andrews Avenue. The following are pictured from left to right: (first row) M. A. Hortt, Ivy Stranahan, and Eva Oliver; (second row) John Miller, Tom Bryan, Ben Tommy, Josie Jumper, and Mr. and Mrs. W. O. Berryhill.

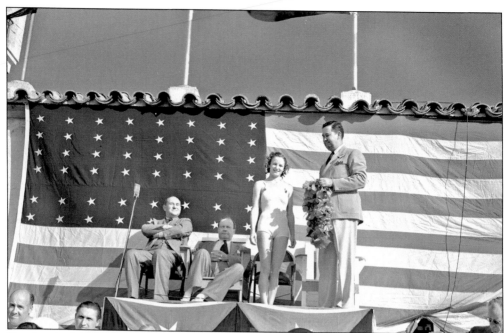

Fort Lauderdale's most famous citizen in the 1930s was champion swimmer and diver Katherine "Katy" Rawls, winner of 26 national and international championships, Olympic medalist (in two sports), and world record holder. Here, overall winner Katy Rawls accepts her prize at the 1936 Annual Collegiate Swim Forum held at the Las Olas Casino Pool (to the east of the present Swimming Hall of Fame) on Fort Lauderdale beach. (H10.9)

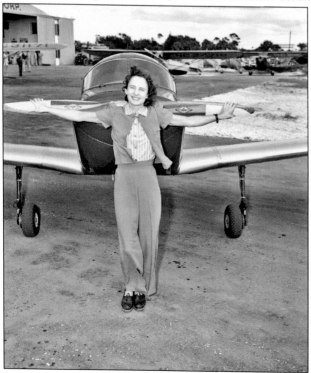

Katy was known for her overall athletic abilities and enthusiasm. After a meeting with Piper aircraft owner W. T. Piper's son, Tony, she added flying lessons to her list of pursuits. She also married her instructor, Ted Thompson. Soon afterwards, Katy was one of 25 women who initiated the Women's Air Force Service Pilots, or WASPs, during World War II. (H10.7)

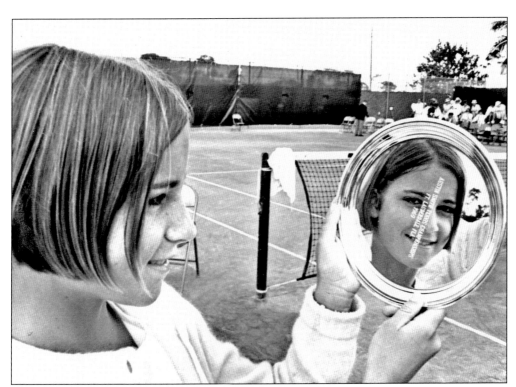

In the early 1960s, Gene Hyde's boss at the *Miami Herald* Broward bureau, Henry Kinney, suggested Hyde stop by the tennis courts at Holiday Park. "There's some kid you should take a look at." The kid was to be one of Fort Lauderdale's most famous citizens of all times, world champion Chris Evert. Gene documented the rising star of this hometown heroine throughout the 1960s and 1970s. Above, c. 1969, young Chrissie poses with the trophy of her first major win, the city of Fort Lauderdale's Austin Smith Tournament. At right, Chris shows off her powerful style against Billie Jean King at the 1972 Virginia Slims tournament in Boca Raton, shortly before turning professional in 1973. (5-15,233 and 5-19,311)

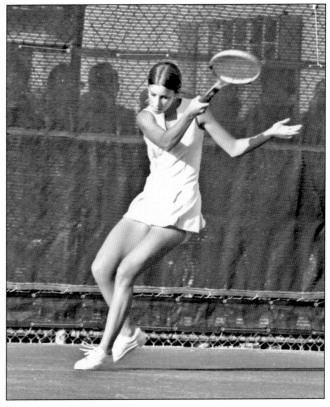

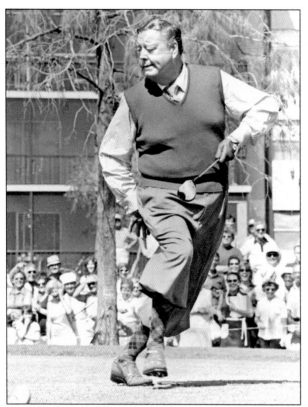

Another one of Broward County's best-known celebrities was comedian Jackie Gleason, the genius behind the popular *Jackie Gleason Show*, which gained fame for Miami Beach in the 1960s. Gleason settled in the development of Inverrary, then a new golf community in Lauderhill. He hosted professional golfers and celebrities in the nationally televised Inverrary tournament, creating tremendous publicity for the growing development. At left, Gleason performs his famous "away we go" shuffle on the links in the early 1970s. Below, Gleason and popular talk show host Mike Douglas pose during the pro-am tournament preceding the Inverrary Classic in 1972. (H46096.1)

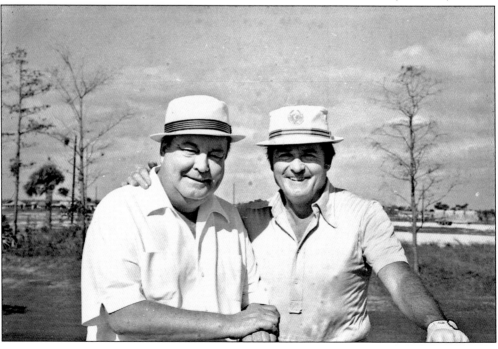

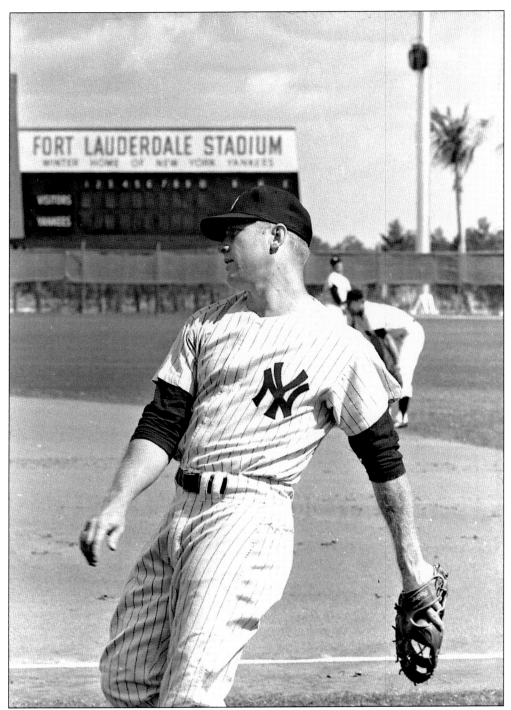

On March 10, 1962, baseball's most successful team and winner of seven World Series between 1949 and 1960—the New York Yankees—opened the new Fort Lauderdale stadium in a game against Baltimore. The magical Yankees called Fort Lauderdale their home during spring training for 33 years. Here Hall of Fame legend Mickey Mantle gets in a bit of throwing practice at the ballpark in 1962. (H29047A.6)

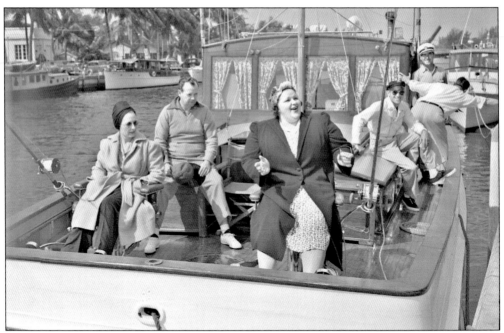

Broward County's beautiful beaches and equable climate have drawn celebrity tourists since the 19th century. Above, popular singer Kate Smith, best known for her rendition of "God Bless America," joins her entourage on a fishing charter on New River in Fort Lauderdale during the 1930s. Note the sweaters and coats—it must have been a cool day. (H22.1)

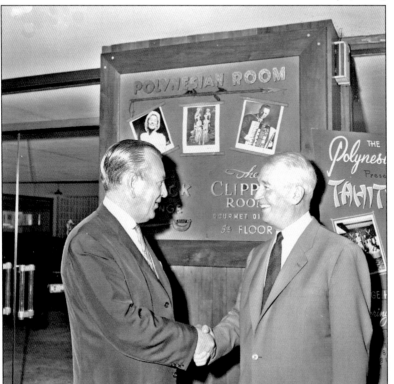

Debonair French actor Maurice Chevalier (left) greets Yankee Clipper manager Tom Brow outside the hotel's famous nightclub, which featured a Polynesian revue, sometime in the late 1950s. (H47809.1)

Gene Hyde captured a very youthful looking Bob Hope as he exits a Mackey Airline flight at Fort Lauderdale airport after a trip to the Bahamas, c. 1954. (H47814.1)

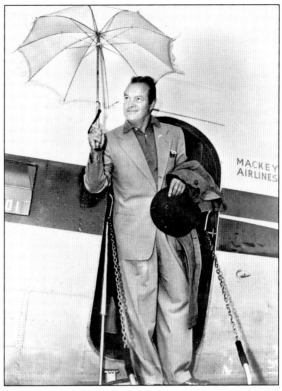

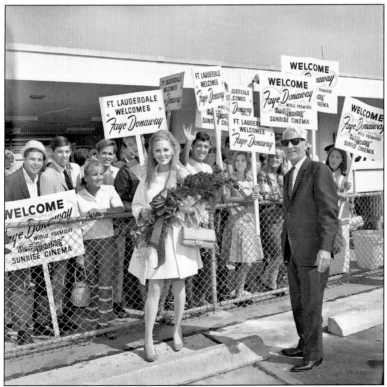

Gene Hyde's favorite actress was Faye Dunaway, one of Hollywood's most in-demand stars during the late 1960s and 1970s. She is shown arriving for the "world premier" of *The Happening,* held at Fort Lauderdale's Sunrise Cinema (today the Sunrise Cinema Galleria theater) on March 22, 1967. (H47777B.1)

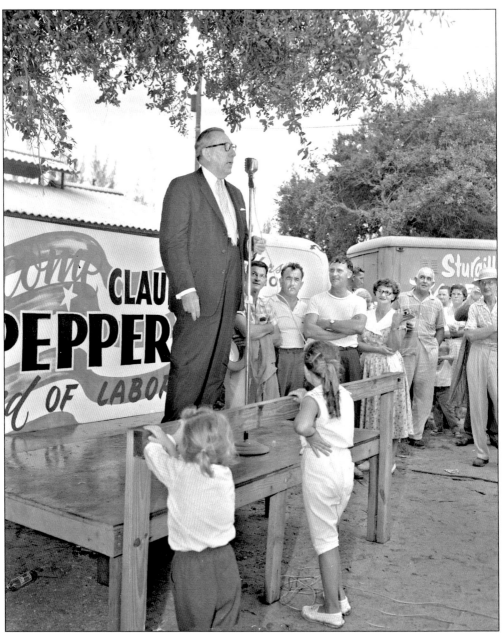

Claude Pepper was seeking a third term as U.S. senator when Gene Hyde captured this classic stumping pose somewhere in Broward County around 1950. Pepper's liberal stances and efforts to appease the Soviet leadership earned him the nickname "Red Pepper" amidst the conservative political environment of the era. Senator Pepper was defeated by George A. Smathers in one of the most notorious campaigns in the history of Florida politics. Pepper returned to Washington in 1963, serving as U.S. congressman until his death in 1989. (H47811.1)

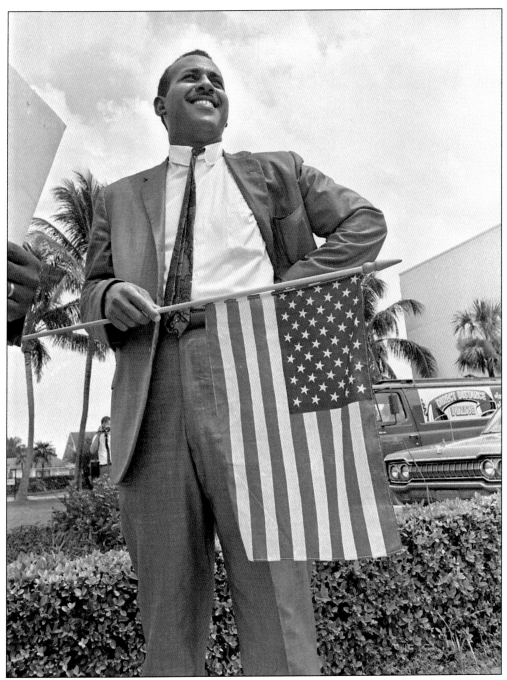

A youthful Alcee Hastings, then attorney for the local NAACP, pauses during a demonstration held protesting alleged police brutality at the Fort Lauderdale Police Headquarters in 1966. A renowned activist in the local fight for civil rights, Miramar resident Hastings was the first African American judge appointed to Florida by Pres. Jimmy Carter in 1979. In 1989, he was impeached and removed from office. In 1992, he became the first African American to be elected to Congress from Florida since Reconstruction, representing parts of Broward, Palm Beach, Hendry, Martin, and St. Lucie Counties. (H43442.18)

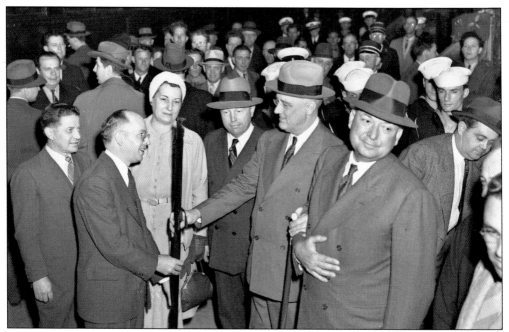

A young Gene Hyde captured Fort Lauderdale officials as they presented President Roosevelt with a fishing rod on behalf of the city in March 1941. From left to right are chamber of commerce president H. L. McCann, Mayor Lewis Moore, commissioner Genevieve Pynchon, White House physician Ross T. McIntyre, Franklin Delano Roosevelt, and Maj. Gen. E. M. Watson, serving as military aid to the president. (H14.1)

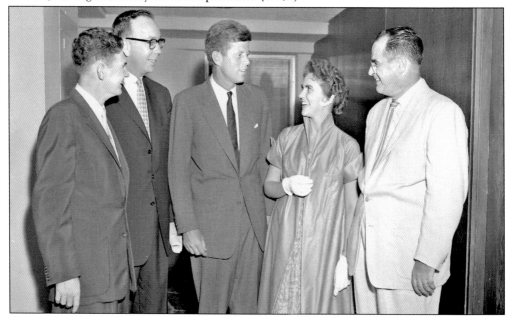

Photographer Gene Hyde was proud of the many American presidents he captured on film. In this picture, an amazingly young John F. Kennedy, then a U.S. senator, with U.S. Congressman Paul Rogers to his left, greets potential supporters at a gathering in Fort Lauderdale, c. 1956. (H47810.1)

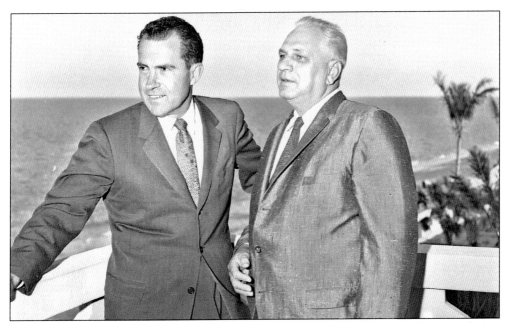

California senator Richard Nixon served as Eisenhower's vice president for eight years during the 1950s. Defeated by Kennedy in 1960, he finally won the oval office in 1968 but was forced into retirement by the infamous Watergate scandal. Here, a rather carefree looking young vice president poses with an unidentified friend on the balcony of a beachfront Broward hotel in the 1950s. (H47812.1)

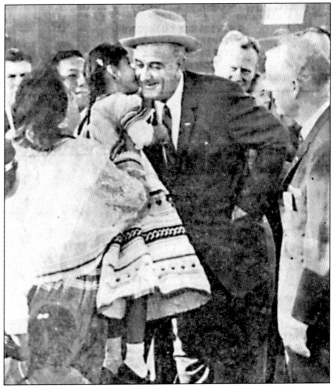

Gene Hyde captured this image of President Johnson at the Fort Lauderdale airport on his way to the dedication of Florida Atlantic University in October 1964. According to the *Herald*, Johnson turned to the photographer and commanded, "Stop taking pictures. Put that camera down." Hyde lowered his camera, whereupon Johnson smiled, "Now let me shake your hand." (*Miami Herald* clipping, courtesy Boca Raton Historical Society.)

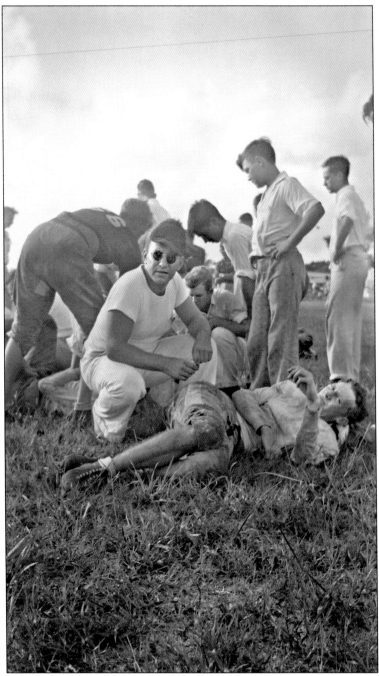

Gene Hyde began his career as a "stringer" for the local newspaper when he was still in high school. One of his most treasured shots was this image of fellow Fort Lauderdale High School student Alexander "Sandy" Nininger downed by a tackle in about 1936. Nininger later graduated from West Point, volunteering for the Philippine Scouts in 1941. In January 1942, Sandy moved beyond American lines against Japanese snipers in Bataan. Despite severe wounds, he killed over 20 of the enemy before he died. For this action, he was posthumously awarded the Medal of Honor, the first to be awarded during World War II. (H2632.1)

Five

THE PASSING SCENE

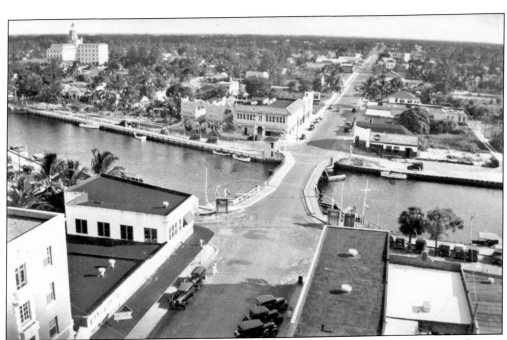

From the 1930s through the 1970s, Hyde's photography captured streets, buildings, and vistas we can scarcely recognize in the 21st century. Some of his earliest photographs document the downtown Fort Lauderdale of about 1934. This image, taken from the top of the city's skyscraper, the Sweet Building (now One River Plaza), shows the Andrews Avenue bridge over New River looking south. To the left of the bridge is the Maxwell Arcade—today the home of the Downtowner Saloon and others. To the left is the rear of the c. 1928 Broward County Courthouse. The modern courthouse stands on the same site. (H381.1)

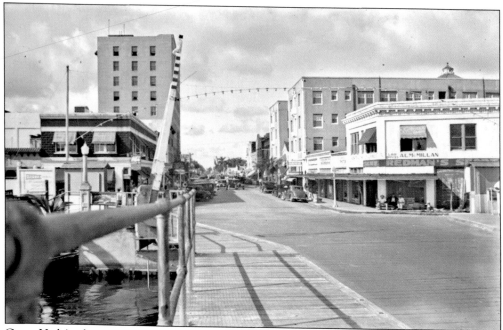

Gene Hyde's photos capture the sometimes subtle (and sometimes not-so-subtle) changes of downtown streets. Above and below shows the scene looking north on Andrews Avenue from the Andrews Avenue bridge. The scene above reveals the styles of the 1930s—the legacy of the boom of the 1920s. The scene below reveals the same structures with a more "streamlined" look, the style of the early 1950s. (H4.1 and H47815.1)

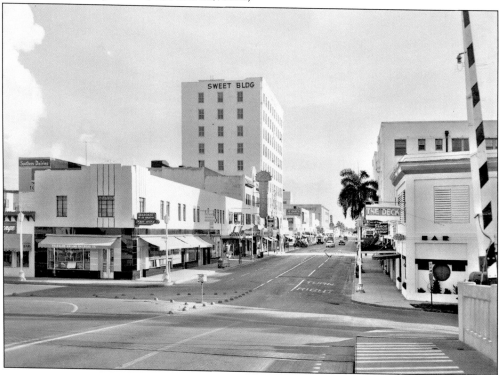

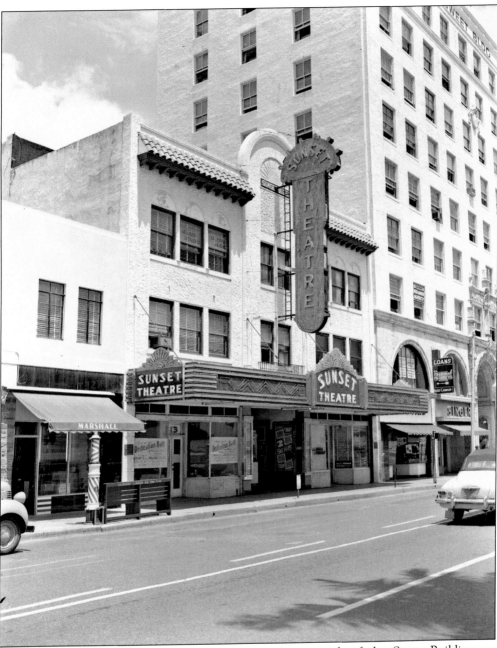

Fort Lauderdale's boom-time Sunset Theatre stood just south of the Sweet Building on Andrews Avenue, just north of the New River bridge in Fort Lauderdale. It played host to live performances as well as "moving pictures" in its heyday, before its closure in 1953, about the time this photograph was taken. The opening night program, dated December 25, 1923, touted it as "a modern temple of entertainment." (H7.1)

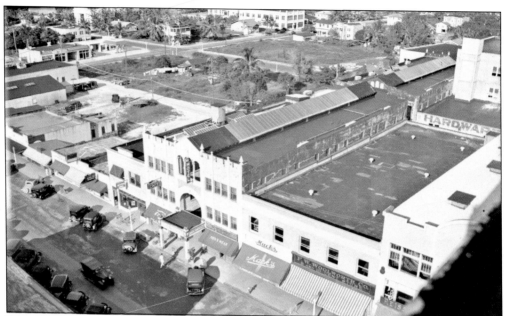

These two views were taken in the early 1930s from atop the Sweet Building looking down onto South Andrews Avenue, Fort Lauderdale's main street. The view above shows the Tropical Arcade, a boom-time office building and hotel, as well as adjacent shops Robbin's and Mack's clothing stores and Woolworth's. Today the Museum of Art stands on this site. To the south of this block stood the Broward Hotel, shown below. The city's first real downtown tourist hotel opened in 1919 and underwent several remodels before its demolition in 1974. (H377.16B and H377.23B)

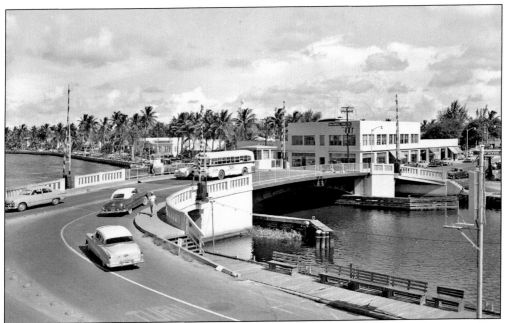

This photograph shows the third Andrews Avenue bridge over New River in downtown Fort Lauderdale a few years after its construction in 1949. At the far side of the bridge is the Maxwell Arcade, also known as the Mediterranean Village. This view is no longer visible; the approaches to the current bridge begin a full block north (and south) of those shown here. (H381.4)

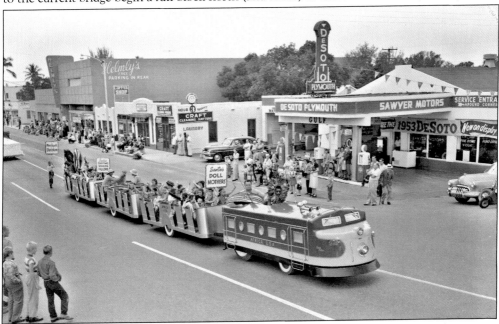

This scene, just south of the Andrews Avenue bridge, also no longer exists thanks to the current bridge approach. Here the mini-train from Africa U.S.A., a Boca Raton tourist attraction, carries Brownies and a cheetah, among others, in a Christmas parade in the early 1950s. The buildings in the background, on the west side of the street, would today be literally under the bridge, in the block immediately south of New River. (H377.20B)

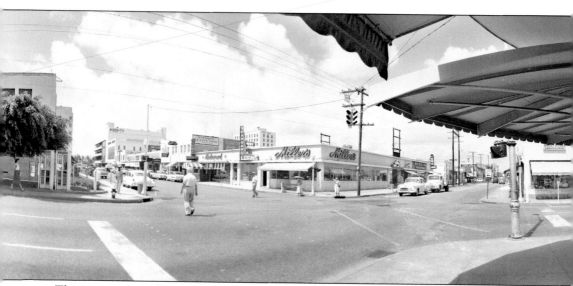

This interesting wide-eye scene captures another view of the Fort Lauderdale long erased from sight. The many retail establishments that once made up the downtown area were "chased out" by the rise of suburban shopping centers in the 1950s and 1960s. Here Gene Hyde turns his camera away from the main streets, capturing an everyday scene at the corner of Southeast Second Street and Southeast First Avenue (the latter extends from the center left of the picture to the far right). Today a person at the same scene would be standing in City Park near the library, looking towards the rear of the large office complex at 200 South Andrews Avenue. (H47816.1)

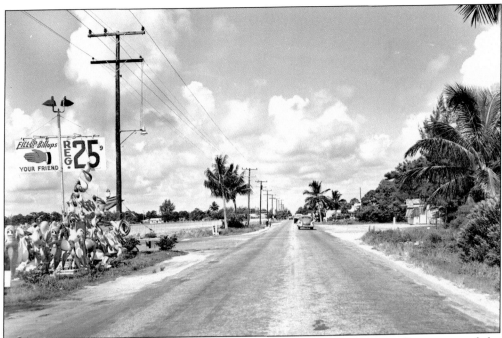

The familiar stretch of East Sunrise Boulevard in Fort Lauderdale between Searstown and the "gateway" is barely recognizable in these two views. Above, East Sunrise is a simple two-lane road in this 1952 image shot at the corner of Northeast Fourteenth Avenue at the eastern edge of Holiday Park. Today's Artserve (the former Fort Lauderdale library) stands at the far side of this corner, on the left. Wooden cottages like the ones shown below once dotted the landscape throughout the county. The rental cottages shown here were located at 1215 East Sunrise Boulevard, c. 1956. (H193.2 and H10434.1)

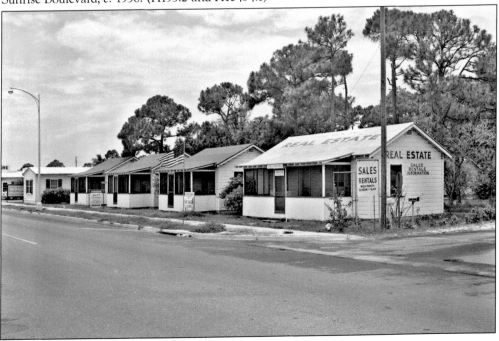

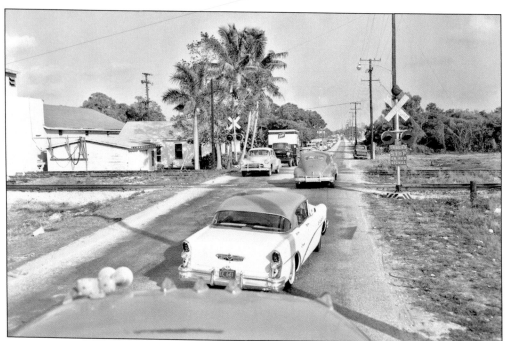

On the west side of Fort Lauderdale, our time machine takes us to another unrecognizable rural road: Broward Boulevard. The photo above shows a traffic jam at the Seaboard Airline tracks (today's Amtrak, just west of I-95) looking east on Broward Boulevard, c. 1955. The interstate should be just up the road—only a dream in the mid-1950s. The image below is the reverse of that above. It captures the scene on Broward from a few blocks east of today's I-95, at the fixed bridge over North Fork of New River, looking west towards the Seaboard tracks. (H9234.4 and H9234.3)

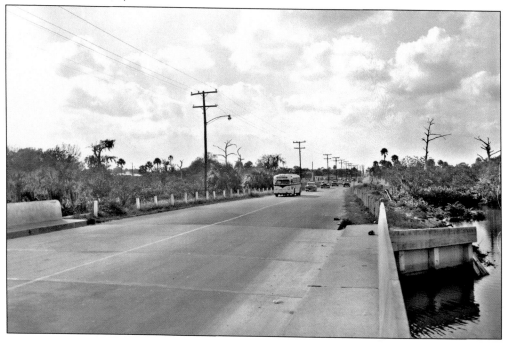

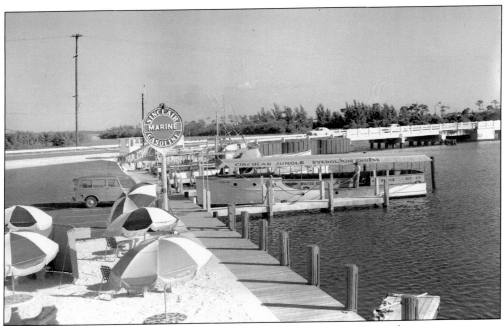

By the 1950s, Fort Lauderdale was experiencing an unprecedented population surge as new subdivisions arose around the urban core. The Coral Ridge development, north of Sunrise Boulevard, encouraged new retail areas like the Gateway and the Sunrise Shopping Center (now the Galleria Mall). Above, this uncluttered 1952 view reveals the newly established Gateway boat docks on Middle River. The bridge at right is Sunrise Boulevard, and the undeveloped land in the background is the future George English Park. Below, young fishermen pose with their catch from the *Seloc III*, docked at the Gateway docks shown above. In the background is newly cleared land awaiting the construction of the Sunrise Shopping Center. (H163.1 and H257.2)

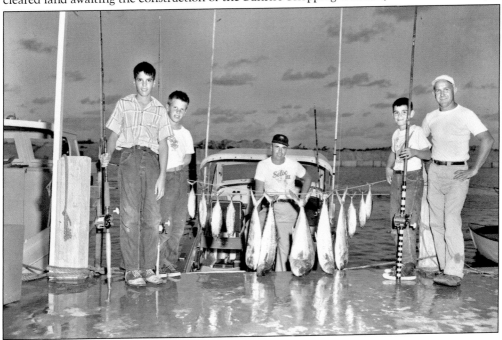

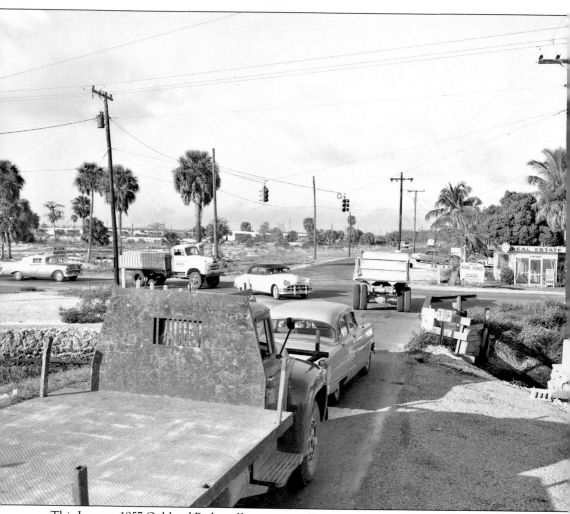

This January 1957 Oakland Park traffic scene is still a familiar site, with just a few changes. Gene Hyde documents the busy intersection of Oakland Park Boulevard and Andrews Avenue, looking west along the boulevard. Today a Publix shopping center stands where the sabal palms once swayed; the real estate office in the photo is on the site of the local Burger King. (H12392.1)

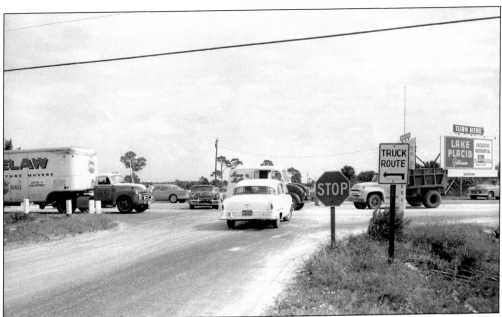

Gene Hyde recorded this photographic assignment as "traffic jam at Sample and Federal." This is a c. 1956 view looking east on Sample (towards Northeast Thirty-sixth Street) to the newly incorporated city of Lighthouse Point. Federal Highway runs horizontally across the picture. The "traffic" was the result of prospective buyers at the new Lake Placid development along the Intracoastal Waterway. (H11760.2)

This Hollywood scene reveals the intersection of Route 9 and Hollywood Boulevard looking southwest in about 1961. The Orangebrook Golf Course is visible at the upper right. State Road 9 was to become I-95, the new expressway making its way up from downtown Miami. It took 13 years to complete the stretch from Hollywood Boulevard to State Road 84 in Fort Lauderdale; it was finally completed in 1968. (H28407.4)

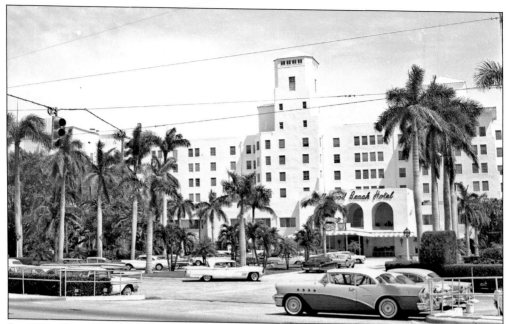

By 1961 when this photo was taken, the Hollywood Beach Hotel's beautiful Mediterranean boom-era style had been covered by extensive remodeling. The landmark was still clearly visible at the foot of Hollywood Boulevard on A1A, however, in the days before a higher bridge was constructed, obscuring the view. (H22343.7)

Yet another of Hollywood founder Joseph Young's original hotels still stood to the east of Young Circle on Federal Highway in 1960. Originally constructed in 1923 as the Hollywood Hotel, it was known in later years as the Park View and finally the Town House, before it was demolished to make way for a new grocery store in 1961. Today the site is occupied by a Publix and other retail establishments. (H20508A.2)

These two photographs capture Hollywood's downtown at mid-20th century. At right, Hollywood Boulevard's commercial district lies ahead in this view looking west from Young Circle in March 1961. The beautiful 1920s Great Southern Hotel stands to the left. Below, another boom-time building, greatly disguised by a modern facade, stands at the corner of North Nineteenth Avenue in 1959. Today most of these structures have survived as downtown Hollywood is enjoying a revitalization begun in the 1990s. (H22433.5 and H19579A.5)

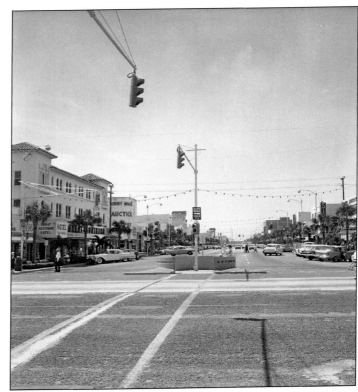

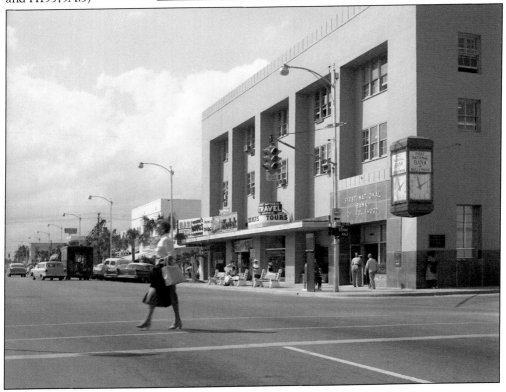

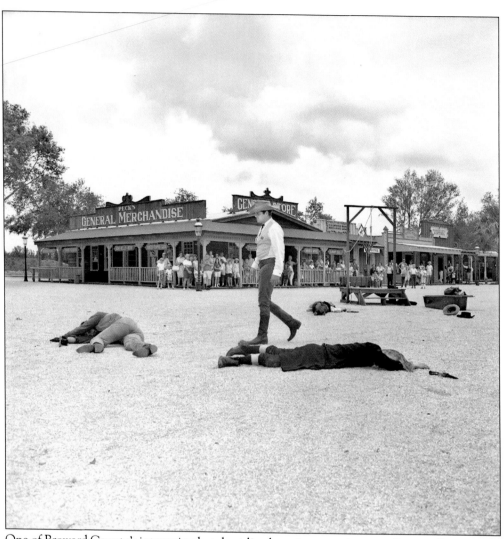

One of Broward County's interesting but short-lived tourist attractions was Pioneer City, an "old west" style town opened by Myron M. Weiss in May 1966. The attraction boasted mock gun battles, a miniature railroad, paddlewheel boats, and stage rides. It was also located in what was considered to be the far western reaches of the county, opposite Flamingo Gardens on Flamingo Road in Davie. In 1968, Pioneer City closed, and the exotic Kapok Tree restaurant stood on the site. Today it is the home of the Stonebrook development. (H47775B.3)

For many decades a Hollywood landmark, the giant alligator and Seminole wrestler marked the entrance to the Okalee Indian Village, a Seminole attraction located on State Road 7 just north of Stirling Road, which opened in 1959. Today the attraction lives on in an abbreviated way, but the site is occupied largely by the new Seminole Hard Rock Casino establishment. (HT27.133)

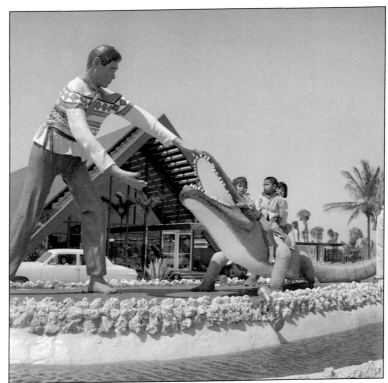

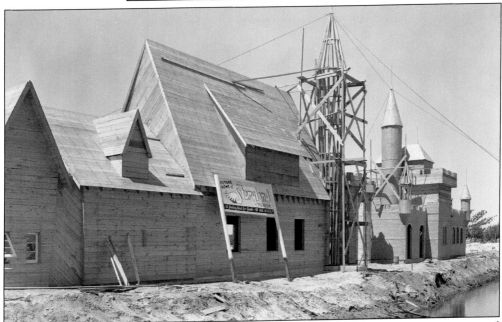

Another new attraction in the 1950s was Storyland, which featured buildings, costumed characters, and rides representing themes from children's fairy tales. It opened in 1955 on a 10-acre site just south of the Cypress Creek Canal (about Southeast Eighth Street) in Pompano Beach. The site was purchased in 1964 by a neighboring auto dealer; Hurricane Cleo put the finishing touches on its demolition later that year. (H8016.5)

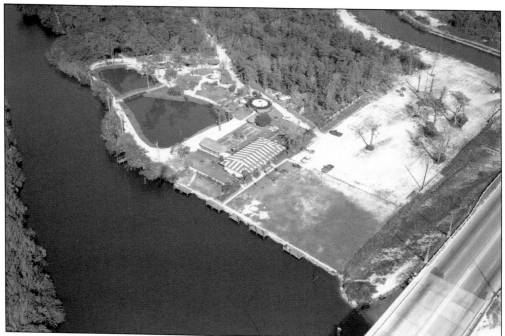

In 1957, a novel tourist attraction called "Aquaglades" opened on the south fork of New River along State Road 84, just west of today's Secret Woods county park and west of the city limits of Fort Lauderdale. Aquaglades boasted elevated walkways with local wildlife, caged animals, the "world's largest fresh water aquarium," and a snack bar and gift shop. It was also well away from the more urbane attractions closer to the beach and closed within a few years. The above photo is an aerial of the site, and the image below shows one of its major "attractions," c. 1957. (H47798.1 and H47798.3)

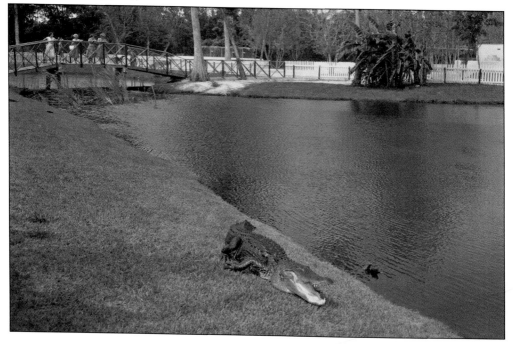

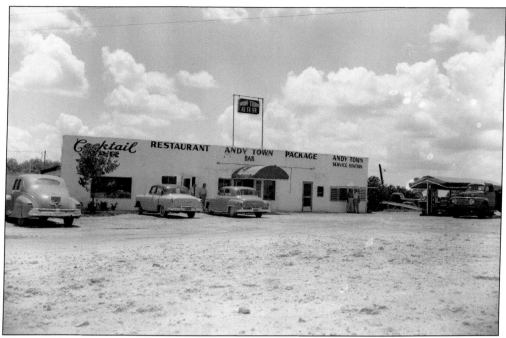

In the early 1950s, Gene Hyde documented novel "communities," which once marked the extreme western end of Broward County "civilization." Travelers venturing out on Alligator Alley (now I-75) found varying types of relief at the legendary Andytown, a glorified truck stop at State Road 84 and U.S. 27. Andytown was demolished to make way for the I-75 interchange at U.S. 27 in 1979. Jo-Mo City, shown below, was a nearby U.S. 27 truck stop named for the letters in the names of owner Roy Jones and associate Castle Moore. Jo-Mo City bit the dust in 1969 to make room for Alligator Alley. (H233.3 and H233.4)

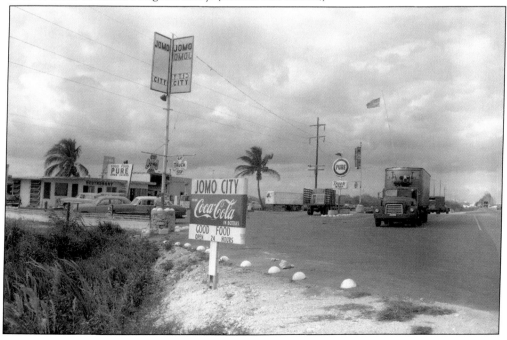

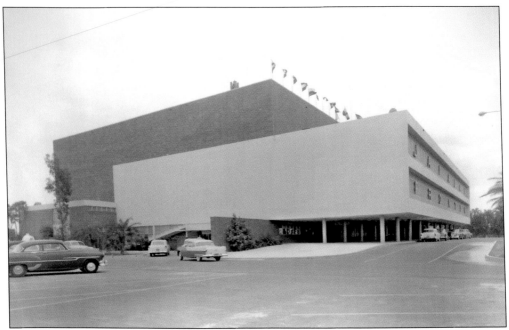

In 1953, the city of Dania became the site of the second jai-alai establishment in the United States. The fronton, designed by Robert Law Weed and Associates, opened the day after Christmas in that year. In the years since, the fronton has continued to host the "world's fastest game," as well as countless graduation ceremonies and other civic events. (H6321.1)

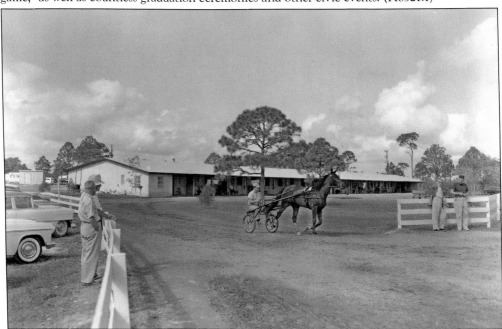

In the 1950s, sportsman Frederick Van Lennep purchased the site of a short-lived boom-time horse track in southwest Pompano and established a training center for trotters and pacers, shown here in 1956. Van Lennep eventually won a long-term campaign to establish a harness track on the site; Pompano Park opened in 1964. (H9093.1)

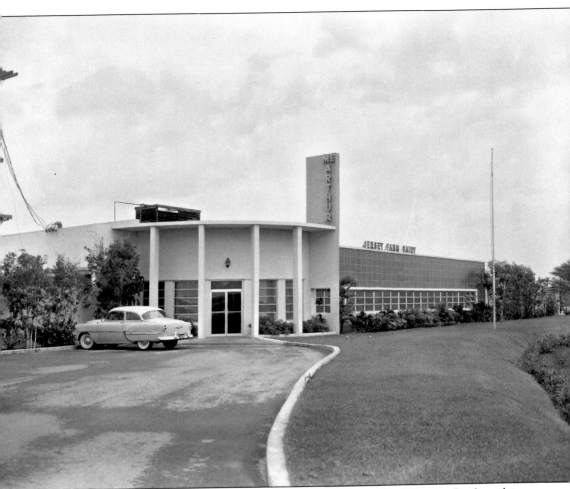

Long a landmark in the "western wilderness" of State Road 7 north of Sunrise Boulevard in what is now Lauderhill, the McArthur Dairy building epitomized Broward County's status as the state's second-largest dairy county in the mid-1950s. Today the swank mid-20th-century building is gone and the property currently lies—however temporarily—vacant. (H1308.2)

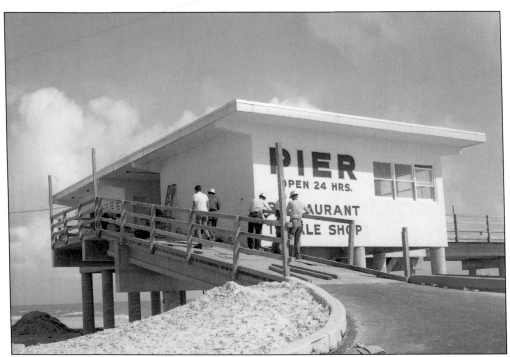

Workers put the finishing touches on a new ramp at the Dania Pier in January 1962. The pier, originally constructed in 1958, closed in 1990 and was not replaced until 1995. (H29041.2)

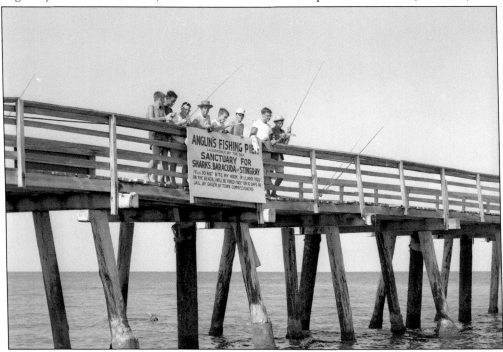

Constructed by pioneer Melvin Anglin in 1941, the pier at the end of Commercial Boulevard has been the small town of Lauderdale-by-the-Sea's main attraction since that time. The old wooden pier, shown here in 1961, has since been replaced with a more modern structure. (H28278.1)

The Deerfield Beach pier located at the end of Northeast Second Street is the focus of beachfront activities at the northern limits of Broward County. The old wooden pier is shown above in the early 1950s. Below is an interesting look from the pier at the modest establishments that once graced the street leading to the pier, Northeast Second Street. A1A (Northeast Twenty-first Avenue, then Ocean Road) veers to the right. The old wooden pier, damaged by 1960 Hurricane Donna, was replaced in 1963. (H514.1 and H514.3)

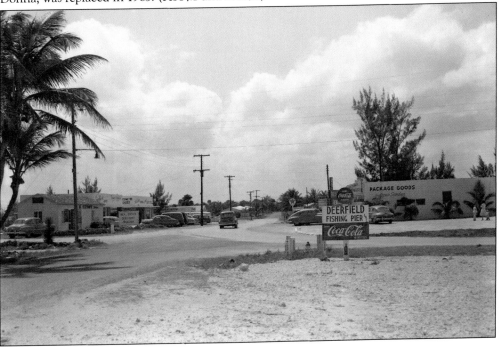

This view depicts Commercial Boulevard, Lauderdale-by-the-Sea's "main drag," c. 1961, looking east in the days before the completion of the causeway over the Intracoastal. The old-timers still speak of the "pre- and post-bridge eras." (H27767.1)

This street scene is actually quite recognizable to those, like the author, who travel it frequently today. It is a view of Wilton Drive in Wilton Manors, looking north from just south of the intersection to Northeast Sixth Avenue—the shortcut to Oakland Park, etc.—shown c. 1962. (H29135.9)

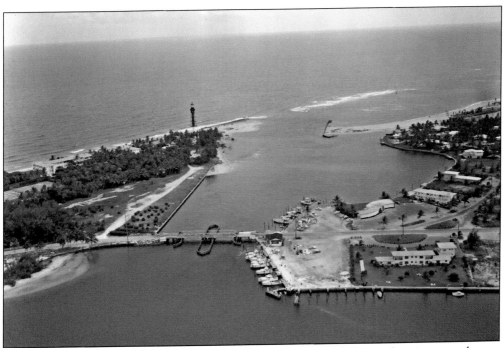

These two aerial shots, taken by Gene Hyde in the 1950s, reveal Broward's quiet coastal areas before the amazing growth of the 1960s. Above, the 1906 Hillsboro lighthouse is visible at the center of this view of the Hillsboro Inlet, *c.* 1956. Note the old swing bridge at center. Below, the city of Hallandale—in the days before beachfront condominiums became synonymous with that community—is shown looking south, *c.* 1952. To the right is the Hollywood Kennel Club, and at upper left is the Gulfstream Racetrack. (H47801.1 and H178.4)

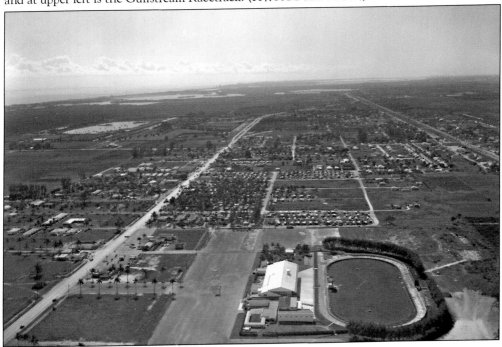

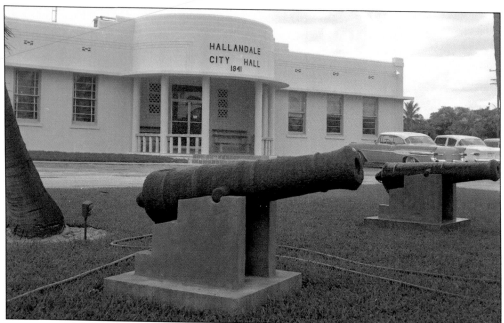

Hallandale's c. 1941 art moderne city hall, shown in 1962, stood on the site of the present municipal center on Federal Highway. The cannons are part of a group salvaged from an 18th-century wreck found off the coast of Hallandale in 1960. They still stand guard on the west side of the current complex. (H29052.4)

Deerfield Beach's city hall was located in the c. 1920 Deerfield School building, which stood at 323 Northeast Second Street in the 1950s. Here, in this c. 1957 view, construction is underway on a much-needed addition called "the commission building." The addition is a parking lot today, but the restored school building still survives as a property of the Deerfield Beach Historical Society. (H13325.1)

Two Broward County courthouses reflect the growth of the county from its creation in 1915 through the 1960s. Shown above, Fort Lauderdale's second school building, located at South Andrews Avenue at Southwest Fifth Street, served as the first courthouse until a new building was opened in 1928. It later housed other county agencies and is shown here shortly before its demolition in the 1950s. Seen below, the 1928 courthouse grew dramatically in the 1960s and was outfitted with a new facade and several additions. This is the view from the parking lot along New River to the north of the building, c. 1963. (H8274.1 and H47803.1)

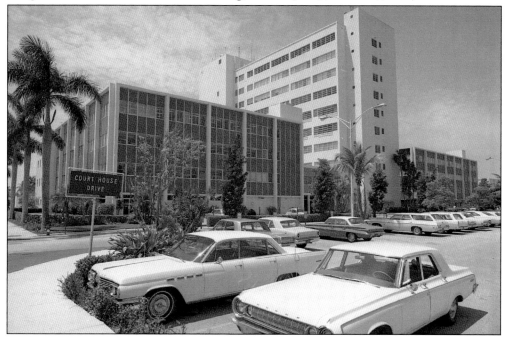

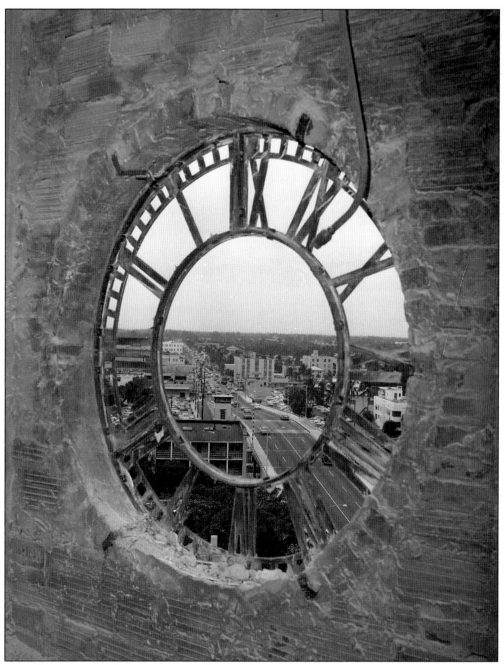

One of Gene Hyde's favorite photographs was this wistful tribute to times gone by. He crawled up into the remains of the tower of the 1928 Broward County Courthouse for one last look out of the old clock face. The view is looking north along Southeast Third Avenue towards downtown Fort Lauderdale. The photo appeared in the newspaper on November 24, 1960. (H21772.5)